KIMONO REFASHIONED

KIMONO REFASHIONED

Japan's Impact on
International Fashion

Edited by Yuki Morishima and Rie Nii

Essays by Akiko Fukai, Cynthia Amnéus,
Katherine Anne Paul, Karin G. Oen,
Yuki Morishima, and Rie Nii

Asian Art Museum
San Francisco

Asian
Art
Museum

Published by
Asian Art Museum
Chong-Moon Lee Center
for Asian Art and Culture
200 Larkin Street
San Francisco, CA 94102
www.asianart.org

Printed and bound in China
21 20 19 18 4 3 2 1 First edition

Library of Congress Cataloging-in-
Publication Data
Names: Morishima, Yuki, 1974– editor. |
Nii, Rie, 1966– editor. | Fukai, Akiko,
1943– Kimono meets the West. | Asian
Art Museum of San Francisco, organizer,
host institution. | Kyōto Fukushoku Bunka
Kenkyū Zaidan, organizer. | Cincinnati Art
Museum, host institution. | Newark
Museum, host institution.
Title: Kimono refashioned : Japan's impact
on international fashion / edited by Yuki
Morishima; essays by Akiko Fukai, Cynthia
Amnéus, Katherine Anne Paul, Karin G.
Oen, Yuki Morishima, and Rie Nii.
Description: First edition. | San Francisco,
CA : Asian Art Museum, [2018] | "Pub-
lished on the occasion of the exhibition
Kimono Refashioned, co-organized by the
Kyoto Costume Institute and the Asian
Art Museum of San Francisco." | Includes
bibliographical references.
Identifiers: LCCN 2018012177 |
ISBN 9780939117857 (paperback)
Subjects: LCSH: Fashion—Japanese
influences—Exhibitions. | Clothing and
dress—Japanese influences—Exhibitions. |
Kimonos—Exhibitions. | Kimonos in art—
Exhibitions. | Kyōto Fukushoku Bunka
Kenkyū Zaidan—Exhibitions. | BISAC:
DESIGN / Textile & Costume. | ANTIQUES
& COLLECTIBLES / Textiles & Costume.
Classification: LCC TT502 .K56 2018 | DDC
746.9/20952—dc23
LC record available at https://lccn.loc.
gov/2018012177

Published on the occasion of the exhibition
Kimono Refashioned, co-organized by the
Kyoto Costume Institute and the Asian Art
Museum of San Francisco

Newark Museum
October 13, 2018–January 6, 2019

Asian Art Museum of San Francisco
February 8–May 5, 2019

Cincinnati Art Museum
June 28–September 15, 2019

This exhibition was initiated by Akiko
Fukai of the Kyoto Costume Institute and
was jointly curated by Rie Nii of the Kyoto
Costume Institute, Yuki Morishima and
Karin G. Oen of the Asian Art Museum of
San Francisco, Katherine Anne Paul of the
Newark Museum, and Cynthia Amnéus of
the Cincinnati Art Museum.

Kimono Refashioned is co-organized by the
Kyoto Costume Institute and the Asian Art
Museum of San Francisco. Presentation is
made possible with the generous support
of The Bernard Osher Foundation, The
Akiko Yamazaki and Jerry Yang Fund for
Excellence in Exhibitions and Presentations,
Michele and Joseph M. Alioto, Warren Felson
and Lucy Sun, Allison and Dan Rose, The
Japan Foundation, and The Henri & Tomoye
Takahashi Charitable Foundation.

THE BERNARD
OSHER
FOUNDATION

The Asian Art Museum–Chong-Moon Lee
Center for Asian Art and Culture is a public
institution whose mission is to lead a diverse
global audience in discovering the unique
material, aesthetic, and intellectual achieve-
ments of Asian art and culture.

Produced by the Publications Department,
Asian Art Museum of San Francisco
Clare Jacobson, Head of Publications

Design and production by Joan Sommers
and Amanda Freymann, Glue + Paper
Workshop, LLC
Edited by Tom Fredrickson
Proofread by David Sweet
Color separations by Professional
Graphics Inc., Rockford
Printed and bound in China

Distributed by
North America, Latin America, and Europe
Tuttle Publishing
364 Innovation Drive
North Clarendon, VT 05759-9436 U.S.A.
Tel: 1 (802) 773-8930; Fax: 1 (802) 773-
6993
info@tuttlepublishing.com
www.tuttlepublishing.com

Asia Pacific
Berkeley Books Pte. Ltd.
61 Tai Seng Avenue #02-12
Singapore 534167
Tel: (65) 6280-1330; Fax: (65) 6280-6290
inquiries@periplus.com.sg www.periplus.com

"One cannot too strongly admire with what happy instinct the Japanese have understood the role of clothing, its decor, its design, its shape, in the air, in the light, in life."

—LOUIS GONSE, *L'ART JAPONAIS*, 1883

CONTENTS

DIRECTORS' FOREWORD

Kimono Refashioned explores the impact of kimono on the world of fashion from the 1870s to now. Featuring works from the renowned Kyoto Costume Institute, it includes Japanese and Western designs, men's and women's apparel, and both exacting and impressionistic references to kimono.

Kimono has impacted international fashion since Japan opened its ports to the world in the 1850s. Motifs used to decorate kimono, its form and silhouette, and its two-dimensional structure and linear cut have all been refashioned into a wide array of garments. Kimono revealed new possibilities in clothing design and helped to lay the foundations of contemporary clothing.

This book and the exhibition it accompanies explore these themes in four sections. The first shows oil paintings from the late 1800s as early examples of the influence of kimono. The next section examines Japonism in fashion from the late nineteenth century to the mid-twentieth century, when new garments were inspired by the motifs, shapes, and cuts of kimono. The third looks at contemporary fashion and its use of kimono's flatness, silhouette, weave, dyeing, and decoration. The final section shows how Japan continues to inspire the world of fashion through its incorporation of popular design, including manga and anime. From a nineteenth-century gown decorated with Japanese flower motifs to a 1960s dress tied with an obi-like sash to recent works by Issey Miyake, Rei Kawakubo, Yohji Yamamoto, and Iris van Herpen, *Kimono Refashioned* makes clear that kimono has had a strong presence in fashion and continues to be a source of ideas for designers worldwide.

We hope that this book inspires readers to consider how clothing is both a cultural expression and a means for cultural exchange. At its most basic level, clothing—like food and shelter—is a simple necessity. Yet like its counterparts, it can be elevated to something much greater. Kimono—literally "thing to wear"—developed into a uniquely Japanese fashion with particularities that set it apart from other clothing. What happens when such garments, articulations of specific places and times, are shared with international audiences? Cross-cultural influences, of course, are multidirectional. How do local styles of dressing change because of interactions with other cultures?

In this spirit of cultural exchange, *Kimono Refashioned* is the product of international collaborations between Japanese and American institutions. We would like to thank the many people who offered their talents and hard work to create this project.

Our great appreciation goes to Akiko Fukai of the Kyoto Costume Institute, who initiated this exhibition. Her vision for this project and her dedication to its realization were essential to its success. We acknowledge Yuki Morishima of the Asian Art Museum of San Francisco and Rie Nii of the Kyoto Costume Institute for editing this publication. The excellence of this volume is due in large part to their tireless efforts. Thanks to the women who jointly curated the exhibition with Morishima and Nii: Karin G. Oen of the Asian Art Museum of San Francisco, Katherine Anne Paul of the Newark Museum, and Cynthia Amnéus of the Cincinnati Art Museum. Their selfless collaboration made what could have been a difficult international project come together and appear seamless.

We are grateful to the staff of all four of the participating institutions: the writers, editors, photographers, and graphic designers who contributed to this book, as well as the conservators, registrars, preparators, and exhibition designers who produced the exhibition. Thanks too to the donors whose generous support makes our work possible. We cannot possibly list all the people who played a part in *Kimono Refashioned*, but please know that we recognize the essential contributions of each individual.

Lastly, we acknowledge the readers and visitors who share our interest in Japan's impact on international fashion. May *Kimono Refashioned* further your curiosity and enthusiasm for the rich culture that clothing expresses.

Jay Xu
Director
Asian Art Museum of San Francisco

Yoshikata Tsukamoto
Chairman
The Kyoto Costume Institute

Ulysses G. Dietz
Interim Co-Director
Newark Museum

Cameron Kitchin
Louis and Louise Dieterle Nippert Director
Cincinnati Art Museum

ESSAYS

A Certain Hypothesis

When I began studying Western costume, I found images of Japan and of kimono reflected in numerous ways in fashion from the nineteenth century onward. I saw garments that were unmistakably inspired by the kimono. I also observed—as others probably have—that the kimono often provided a simple, quick means of creating an aura of exoticism; indeed, the kimono is still used today as a beautiful outfit symbolic of Japan on stage and for dressing up. Yet when painters such as James McNeill Whistler (1834–1903), Édouard Manet (1832–1883), and Claude Monet (1840–1926) were exposed to "Japan" and the revelation of its distinctive aesthetic in the second half of the nineteenth century, they soon went on to produce marvelous artworks full of personal creative innovation, far surpassing mere exoticism.

Could there be a similar significant relationship between kimono and fashion? The 1920s dresses of Madeleine Vionnet (1876–1975) triggered this question in my mind. Her extremely simple, linear garment patterns were completely different from the complex curves of traditional Western dressmaking. They had much in common with kimono. So maybe the interest in kimono was not simply about the attraction of the exotic, after all. This hypothesis began to take shape in the context of the early-twentieth-century transition to modern clothing, when fashion searched for novel ideas in a quest for fundamental change. Nor had the fervor of Japonism, in its more general sense, yet been toned down in that era. As I had suspected, the West had moved beyond its initial superficial interest in the kimono's exoticism to appreciate it on a deeper level. Fashion adopted the kimono in steps and from several different angles. Furthermore, these responses clearly demonstrate that, when borrowing ideas, modern fashion frequently turned to prototypes for inspiration.

Kimono and Japan Today

The kimono is a garment unique to Japan. Its characteristic T-shape, the way it is draped, its refined textile designs—all have fascinated people in many different cultures and periods. Even today the kimono continues to stimulate fashion designers in a variety of new ways, providing a wealth of inspiration. Alternatively, the term might make some people think of the kimono-style dressing gown that established itself in the Western wardrobe after the "kimono boom" at the beginning of the twentieth century.

When Europeans and Americans encountered the kimono in the mid-nineteenth century, it invited them into the unknown country of Japan, arousing a fascination akin to adoration. In every respect, the kimono was quite different from Western clothing—the nonchalance of

the way it was worn, the curious decorative tie at the back, the elegant long sleeves, and the beautiful fabric adorned as though it were a painting on a large canvas. As such, it captivated a great many people, including painters like Whistler and writers such as Edmond (1822–1896) and Jules de Goncourt (1830–1870).[1] At the same time, Western admirers immediately recognized the sophistication of the dyeing and weaving techniques used to create these alluring garments. In fact, during the Edo period (1615–1868), when Japan was isolated from foreign countries, these techniques reached a level of development and originality not seen elsewhere. Replete with novelty and refinement, the kimono's arrival in the West heralded an unexpected and important role for the garment on this new stage.

In the Meiji period (1868–1912), Japan embarked on a policy of adopting Western culture, bringing significant changes to the lives of Japanese people who had worn kimono for many centuries. Separate terms were coined to distinguish Western clothing, *yōfuku*, from customary Japanese attire, now called *wafuku*, as traditional clothing ceded its primacy to Western dress. At the same time the meaning of the word *kimono*—literally "thing to wear"—narrowed in scope; it now referred to the descendent of the *kosode*, the precursor of the modern kimono.

After World War II, Western clothing became the norm in Japan, universally accepted as everyday wear. If Japanese fashion today has a worldwide reputation for creativity, it can be partly attributed to the prominence since the 1980s of Japanese fashion designers such as Issey Miyake (b. 1938), Rei Kawakubo (b. 1942), and Yohji Yamamoto (b. 1943). Nevertheless, the rich traditions and highly developed production techniques associated with kimono are still part of Japan's dress culture today. It continues to provide an infinite source of inspiration and repeatedly reinvents itself in different ways.

The West Meets the Kimono

The Western world encountered kimono in the seventeenth century. During the Edo period, Japan maintained a policy of national isolation for more than 200 years, but even during this time the Dutch East India Company was able to continue trading with Japan. Thus, kimono reached Western Europe through the Netherlands, where, in the seventeenth century, they became highly fashionable as men's dressing gowns known in Dutch as *Japonsche rocken*. Similar items soon appeared in Britain and France called *banyans* and *indiennes*, respectively. *Japonsche rocken* were adapted from the Edo-period padded kimono used for sleeping. Known for its rarity and practicality—its light weight and warmth—the kimono often appeared in contemporary paintings as a symbol of affluent urban life, and actual examples of the garments can be found in Dutch

Fig. 1
The Princess from the Land of Porcelain, 1863–1865. By James McNeill Whistler (American, 1834–1903). Oil on canvas; H. 200 cm x W. 116 cm. Freer Gallery of Art, Smithsonian Institution, Washington, DC, F1903.91a–b.

Fig. 2
Japanese women at a teahouse at the 1867 Exposition Universelle in Paris in *Illustrated London News*, November 16, 1867.

Fig. 3
Sortie de bal, "Japonais" (Japanese-style evening wrap) in *Journal des Demoiselles (Young Ladies' Journal)*, October 1867.

museums.[2] The Peabody Essex Museum in Salem, Massachusetts, has a very important piece brought to the United States by Captain James Devereux (1766–1846) at the end of the eighteenth century, when the Americans were trading with Japan through a roundabout trade agreement via the Dutch East India Company. It is very likely the oldest kimono brought to America.

The kimono entered a new stage after Commodore Matthew Calbraith Perry (1794–1858) led the first US navy ships into Uraga in 1853, ushering in the end of Japan's long policy of isolation the following year. Cultural interchange between East and West suddenly burgeoned on a wave of international expositions that had begun in London with the Great Exhibition of 1851. A wide range of Japanese items, from art objects and decorative arts to daily utensils, were exported in vast quantities, triggering the boom in Europe and America known as "Japonism." It is well known that ukiyo-e (Japanese woodblock prints) were admired across the world at this time, exerting a powerful influence on Western art; of the various other Japanese objects exported, kimono was the focus of particularly close attention.

In the early 1860s kimono began to feature in paintings by European and American artists—for example, Whistler's *The Princess from the Land of Porcelain* (fig. 1).[3] At first it fascinated people as a prop evoking the exotic image of the unknown Far Eastern land of Japan. Women wore kimono to dress up as Japanese ladies, or kimono were used as drapery in the latest trend for interiors with Japanese embellishments. An early example can be seen in *Young Women Looking at Japanese Articles* by the French painter Jacques-Joseph James Tissot (1836–1902; cat. 1).

The kimono appeared on the Parisian fashion scene in 1867, the year of the Exposition Universelle, when Japan officially participated in a world's fair for the first time. A Japanese-style teahouse was set up at the venue, and visitors were fascinated by three kimono-clad ladies sent from Japan to serve tea (fig. 2). Soon after the exposition, an illustration of a Japanese-style evening wrap was published in *Journal des Demoiselles*, suggesting the exposition's influence on continental style (fig. 3). Kimono fabric was used to make fashionable clothing in Paris and London in the 1870s and 1880s, as in a half-length coat possessed by Princess Mathilde Bonaparte (1820–1904) that is very similar in shape to the one in the illustration.[4] The French art critic Ernest Chesneau (1833–1890), who played an important role in the vogue for Japonism, praised the superb dye work, embroidery, weaving, and designs that conjure up the seasons of the year found in Japanese kimono as well as taking an interest in the obi, the traditional sash worn with kimono.[5]

sode	sode	migoro	migoro	okumi	okumi
				eri	eri

FRONT BACK

Refined Textile

The kimono can be traced back to the second half of the eighth century, and by the latter half of the sixteenth century it had assumed the shape we know today; since that time, the kimono has not undergone the major changes in form seen in Western dress. Its most striking feature is its construction, consisting of rectangular pieces of fabric sewn together (fig. 4). It retains the same basic shape regardless of the silhouette or curves of the human body or the figure or gender of the individual wearer. This means that the distinctiveness of each garment necessarily derives from its fabric and its design, and the rectangular construction of the kimono was often treated as a canvas for pictorial expression. Unique weaving and dyeing techniques were developed for this purpose. Designs were sketched onto the fabric, and then a whole array of decorative techniques—including dyeing, *shibori* (resist-dye methods

Fig. 4
Kimono pattern.

sode: sleeve
eri: collar
migoro: front body panel
okumi: front gore
fuki: turned-back hem/narrow strip at the hem where the lining is turned up to show on the front

Fig. 5
Arrangement in Grey and Black No. 1, also called *Portrait of the Artist's Mother*, 1871. By James McNeill Whistler (American, 1834–1903). Oil on canvas. H. 144 cm x W. 163 cm. © RMN-Grand Palais (Musée d'Orsay) / Jean-Gilles Berizz.

including stitch and bind, wrapping, and tie-dyeing), embroidery, and gold- and silver-leaf imprint were utilized, with a host of highly skilled artisans specializing in each technique. Although the kimono is no longer Japan's primary mode of dress, these traditions remain a steadfastly preserved undercurrent in the Japanese clothing industry.

The kimono favored by Western painters and fashionable ladies in the latter half of the nineteenth century were called the *kosode* and the *uchikake* (a loosely draped outer garment),[6] worn by elite ladies of the Japanese warrior class. Many of these garments were decorated with so-called *goshodoki* (imperial court-style) designs, in which traditional motifs, such as seasonal flowers and plants or flowing water, were dyed in various colors onto a silk-figured satin (*rinzu*), crepe (*chirimen*), or, in summer, silk gauze (*ro*) before additional decoration such as embroidery was added. Numerous Western museums acquired kimono of this

type, their highly sophisticated and ornate designs perfectly matching nineteenth-century European and American taste.

Because the kimono could easily be spread out flat, it was often used as drapery for interior decoration. We have one example in Tissot's *Young Women Looking at Japanese Articles*; in Whistler's *Arrangement in Grey and Black No. 1* (fig. 5) we see a dark gray *kosode* hanging like a curtain before the artist's mother. In Manet's *Autumn* (1881), a sky-blue *kosode* serves as a backdrop for the figure of Méry Laurent, creating a setting that symbolizes autumn. William Merritt Chase (1849–1916) likewise included kimono in his works; his subjects often wore one as a dressing gown, particularly in the late 1880s and 1890s.[7]

As noted above, kimono were remodeled into fashionable clothing items or worn unmodified as luxurious dressing gowns. An early example of the latter can be seen in *Meditation* (c. 1872) by the Belgian painter

Alfred Stevens (1823–1906). By the 1880s this usage had become widespread, as when Pierre-Auguste Renoir (1841–1919) painted *Madame Hériot* (1882; p. 49, fig. 2), his sitter sporting a white kimono with *goshodoki* design as a fashionable dressing gown. She wears her kimono over an orange dress and fastened with a belt matching the dress. This Western manner of wearing the kimono, unthinkable to the Japanese, was totally innovative.

The kimono's loose form and fit, as well as its exotic novelty, led Westerners to adopt it for use as a dressing gown.[8] Around 1900 the word "kimono" began to appear in women's magazines, referring not only to the traditional Japanese garment but also to a new type of loose-fitting dressing gown.[9] The Japanese actress Sadayakko Kawakami (1871–1946) played an important role in expanding the popularity of the kimono. After touring America with her husband, Otojirō Kawakami, and his theater troupe, she performed at the 1900 Exposition Universelle in Paris and achieved a new level of celebrity: her photographs appeared in theatrical journals and women's magazines, and Pablo Picasso (1881–1973) sketched her on stage.[10] Her fame led the Paris shop Au Mikado to promote a garment called the "Kimono Sada Yacco,"[11] which was sold in stores and by mail order until the outbreak of World War I and became widely known in France and neighboring countries such as Spain and Italy. The Paris fashion house Babani sold higher-quality kimono-style dressing gowns that were well received with fashionable ladies as far away as the United States.[12] During this time economically priced "kimono" were sold through the Liberty and Sears, Roebuck mail-order catalogues and gained great popularity among the middle classes of Britain and America.[13]

The Kimono's Reception in the Paris Fashion Scene

The trend of remaking kimono into fashionable Western clothing—a practice that continues to this day—began in Paris and London in the second half of the nineteenth century. Around 1890 garments bearing Japanese motifs such as chrysanthemums, irises, flowing water, sparrows, splashing waves, and sheaves of rice appeared on the Paris fashion scene. Couturiers such as the House of Worth and Jacques Doucet introduced dresses with patterns resembling silk kimono and obi fabrics. Designers employed materials produced by textile makers in Lyon (see cat. 6). Another wave of Japanese-style adornments swept through Paris fashion in the 1920s (see cat. 16). Since then, decorations used for kimono fabrics—along with other Japanese motifs—have become firmly established in the repository of Western textile design and continue to emerge periodically on the fashion scene (see cat. 38).

Interest in the kimono's distinctive shape expressed itself in imitation of such features as the sleeves or obi, as seen in the *Journal des Demoiselles* illustration of 1867 (fig. 3). At the beginning of the twentieth century a French magazine declared "the need to mention Japonism in fashion . . . as one of the novelties of the moment."[14] This particular flare of French attention to Japanese style was sparked by Japan's victory in the Russo-Japanese War in 1905, leading to a kind of "Japanese craze" in theatrical circles along with numerous exhibitions of ukiyo-e prints.[15]

From around 1907 to 1913, renowned fashion houses such as Callot Sœurs, Lucile (see cat. 13), and Paul Poiret (1879–1944; see cat. 15) created a steady stream of garments reminiscent of the outfits worn by beauties in ukiyo-e. In this era, models posing for fashion magazines strongly reflected the look depicted in prints by Kitagawa Utamaro (c. 1753–1806) and Katsushika Hokusai (1760–1849), with models glancing back over the shoulder in garments with kimono-like sleeves, cocoon-shaped forms, trailing hems (*ohikizuri*), low-backed necklines, and so on. These features of kimono continue to fascinate designers today.

Poiret was one of the first couturiers to take an interest in the way the kimono was constructed—in his autobiography he referred to a 1903 design as a "kimono coat"[16]—and he was particularly interested in its loose fit. He certainly had the kimono in mind, along with the straight-cut construction of ancient Greek garments and European peasant wear, when he proposed corset-free fashions in 1906.

The straight lines of the kimono took on greater significance in the 1920s, as the postwar society demanded more practical women's clothing, along with shortened skirt lengths and haircuts. Talented new designers such as Madeleine Vionnet and Coco Chanel (1883–1971) gave concrete form to this radically different mode of clothing for the modern and independent woman. Chanel broke new ground by bringing the functionality of menswear into women's clothing, while Vionnet departed from the curved cuts hitherto used in Western garment construction and adopted the then-novel approach of straight, linear cuts to create her pieces.[17] The long, narrow, tubular dresses characteristic of the 1920s were innovations in Western fashion and continued to exert a huge influence throughout the twentieth century.

There is no doubt that Vionnet studied kimono intensely. While working at Callot Sœurs, she was influenced by one of the house's founders, Marie Callot Gerber (d. 1927), the eldest of the sisters, a close friend of Edmond de Goncourt, an advocate of Japonism, and a collector of ukiyo-e and kimono. Vionnet departed from the framework of Western European clothing by applying the compositional principles of kimono, borrowing features such as large sleeves or kimono-type openings in her own work, as well as utilizing kimono-fabric motifs.[18] She adopted the linear principles of the kimono and utilized its methods of construction (see cat. 17). Her tubular dresses of the mid-1920s (see

cat. 18) were made from rectangular pieces of fabric that, like kimono, completely obscured the female body. Vionnet is perhaps best known today for the so-called bias-cut dress. As Betty Kirke has pointed out, the straight cuts of kimono provided a foundation directly leading to that groundbreaking innovation.[19]

Vionnet clearly understood many aspects of kimono, and kimono's influence surpassed that of Japonism on her work. Western dress was ripe for modernization, and it urgently sought new strategies to do so. Designers such as Vionnet were able to give this desire concrete expression in the form of actual clothing: kimono provided a novel creative vocabulary that triggered a conceptual shift in Western dress design. The tube-shaped garments of the 1920s did not emphasize the curves of a woman's body as had earlier Western clothing; they covered the body without being molded to an individual figure. This abstracted, standardized format was not gender differentiated, and so created a unisex garment. It was precisely this distinctive morphological trait of the kimono that influenced Western clothing and enabled it to distance itself from the human figure and move toward freer shaping of garments. We can see the culmination of this trend in the innovative creations of Cristóbal Balenciaga (1895–1972).

The Future Potential of the Kimono

Japanese fashion designers emerging at the end of the twentieth century took this direction even further. In the early 1980s they pioneered bold, imaginative clothing that departed from traditional Western garment construction. In so doing, they struck a blow against Western hegemony in the fashion scene. While these designers attained popularity around the world, a certain "Japanese-ness" clung to their work, whether intentional or not. However, theirs was not the rich, colorful aesthetic of ukiyo-e that had attracted attention in the time of Japonism;

rather, their work celebrated the diametrically opposed Japanese quality of *wabi-sabi*, a minimalist approach that had echoes in twentieth-century modernism, principally in architecture and other fields of design. Japanese fashion of the 1980s prioritized this reductive aesthetic precisely because it needed to break with fashion of the status quo and head in new directions.

While their clothes were criticized for having no form in the Western sense, Japanese designers such as Miyake and Kawakubo produced superb creations that freed clothing from following the contour of the human figure. In their commitment to abstract garment formats they have extended kimono tradition. It is fair to say that the kimono's independent shape, distinct from the human figure, plays a dominant, intrinsic role in how Japanese designers shape their garments.

The kimono's distinctive profile, the way it is worn, its motifs, and its construction all continue to provide fashion with a multifaceted wealth of ideas. Notably, owing to their uniform shape, kimono were differentiated primarily by their textiles. Even now, when the Japanese wear Western dress, they continue to nurture and preserve a wide variety of sophisticated traditional dyeing and weaving techniques, which fascinate designers around the world.

In the twenty-first century, Japanese pop and graphic arts have attracted worldwide attention thanks to the popularity of manga and anime. One can see these mediums as part of an unbroken tradition rooted in Edo-period culture. This bold sensibility first was transmitted to the Japanese middle classes through kimono culture (see p. 21, fig. 3) and now moves from kimono to T-shirts and other modern garments. Kimono may no longer be considered items of everyday clothing, yet kimono's legacy—the concepts underlying its construction, its textile techniques, and its graphic designs, all tied to sensibilities honed over centuries—will undoubtedly continue to pulse through contemporary fashion around the world.

Cynthia Amnéus

WEARING JAPONISM

Tradition and Variations on the Kimono

Preceded by the Portuguese and Spaniards, who were expelled in 1624 and 1639, respectively, the Dutch arrived in Japan in the early seventeenth century. They were the only Europeans granted official trading rights throughout Japan's *sakoku*, a self-imposed period of isolation that lasted until the mid-nineteenth century. As required by the ruling shogun, the Dutch appeared at court annually in Edo (now Tokyo) to secure permission to continue trading activities. Part of this ceremony involved an exchange of gifts. The Dutch offered textiles, exotic animals, and other curiosities and in return received padded silk kimono, or *rocken*—a Dutch term for overgarments or gowns.

Fashioned from silk, *Japonsche rocken* sent back to the Netherlands were welcomed as sumptuous, ample, and comfortable garments. Worn like a housecoat or dressing gown, *rocken*—accessorized with lace cravats and cuffs and full-bottomed wigs—were often the attire of choice in portraits of Dutch men. As evidenced by extant garments in museum collections, Dutch *rocken*—and similar forms adopted by a wider audience of Europeans and Americans—continued to be worn throughout the eighteenth century.[1] The capaciousness of the garment and its lack of tailoring were the antitheses of Western modes, which were constructed to conform to the figure's contours. In time, the Japanese kimono was adapted in the West as a less constricting style of dress, divorcing this garment from its authentic use as traditional attire.

The establishment of trade relations between the United States and Japan by Commodore Matthew Calbraith Perry (1794–1858) in an 1854 treaty facilitated similar agreements between the shogunate and other Western powers, including Britain and France. Although some Asian decorative arts had been exported to Europe prior to Perry's visit, his successful arbitration led to a proliferation of Japanese goods in the early 1860s in Paris and London shops, including La Porte Chinoise and the Oriental Warehouse.[2] These establishments were frequented by contemporary artists, including James McNeill Whistler (1834–1903), Édouard Manet (1832–1883), Edgar Degas (1834–1917), and Dante Gabriel Rossetti (1828–1882), who were fascinated by the peculiar aesthetic qualities of this material.[3]

While these curio shops fed a particular clientele, the wider public was introduced to Japanese aesthetics through world's fairs. At the 1862 International Exposition in London, Rutherford Alcock (1809–1897), Britain's first consul general to Japan, exhibited more than 600 pieces from his personal collection, including lacquerware, baskets, ceramics, metalwork, textiles, prints, and ivory carvings.[4] While Alcock's collection formed the basis of the Japanese exhibit and purportedly delighted visitors, the Japanese embassy was less than impressed. This display of objects, which in their eyes did not convey the sophistication

of Japan's arts, emboldened the Japanese to directly participate in the 1867 Exposition Universelle in Paris.[5]

The acclamation generated by Japan's 1867 display motivated the new Meiji government (1868–1912) to require participation in future expositions. These occasions provided the Japanese with opportunities to not only demonstrate the quality of their own work but acquire knowledge of Western skills and technology—and promote the export of arts and crafts among their own people.[6] To this end, the port city of Yokohama, which had opened to foreign trade in 1859, quickly became just such a gateway for East-West exchange. The streets were lined with souvenir shops and export companies established by Japanese businessmen. One such merchant was Shiino Shōbei (1839–1900), who began his career selling silks and various other items and became one of Yokohama's foremost merchants. Shortly after visiting the Vienna International Exposition of 1873, Shiino seized the opportunity to manufacture Western-style dressing gowns with a Japanese singularity that would be desirable to foreigners. Dressing gowns made in the West—comfortable garments meant to be worn at home, in the boudoir, and among one's most intimate family members—were less tailored than fashionable day or evening wear. This deviation from a made-to-measure approach enabled Shiino to manufacture a similarly relaxed example in Japan for direct export. Characterized by a modicum of fit at the waist, a center front opening, high neckline, long sleeves, and a slight train, Japanese-made dressing gowns were constructed of a plain-woven silk that was vertically quilted, often with a contrasting color for the collar or lapels, cuffs, and pockets and fancy twisted cord closures and belts. Embellished with Japanesque designs executed in hand-worked embroidery in twisted silk thread, they were advertised widely in fashion magazines and became popular among European and American women alike (see p. 118, dressing robe).[7]

In the late nineteenth and early twentieth centuries, exposure in the West to Japanese aesthetics was advanced through various vehicles. For instance, in 1876 and 1877 famed designer Christopher Dresser (1834–1904) spent four months traveling in Japan, subsequently publishing his landmark book *Japan: Its Architecture, Art, and Art Manufactures* (1882). Gilbert and Sullivan's comic opera *The Mikado* debuted in London in March 1885 and was a success across Europe and America. Just prior, the Japanese Village opened in Knightsbridge, London—a commercial venture populated by approximately 100 Japanese natives—and in 1886 a similar enterprise was launched in the United States, touring Boston, New York, Philadelphia, Chicago, Cincinnati, and San Francisco.[8] Pierre Loti (1850–1923) published his novel *Madame Chrysanthème* in 1887, adapted by Giacomo Puccini (1858–1924) as *Madama Butterfly* in 1904.[9] From 1888 to 1891 art dealer Siegfried Bing (1838–1905) published monthly editions of the

Fig. 1
Kimono and Sash, approx. 1920. Japan, Shōwa period (1926–1989). Silk crepe damask, silk embroidery thread, and silk fringe. *Cincinnati Art Museum, Gift in memory of Mrs. William Leo Doepke (Ethel Page) by her granddaughter, Sara Doepke, 2012.95a,b.*

periodical *Le Japon artistique (Artistic Japan)*, having opened a shop selling Japanese objets d'art in Paris in the 1870s.[10]

While such presentations of genuine Japanese arts and Western interpretations of the same were consumed by the general public, Japanese aesthetics were acutely observed by artists of the period. Fueled by such exposure, contemporary painters and printmakers incorporated these concepts—and images of actual objects—into their work. Perhaps the most vivid case was French artist Jacques-Joseph James Tissot (1836–1902), who was an avid collector of Japanese art, including kimono. The son of a linen draper and a milliner, Tissot frequently situated women and their elegant clothing as the focus of his paintings.

The Japanese Bath from 1864 is Tissot's most provocative picture in which a finely detailed garment is given prominence. With sliding Japanese doors and cherry blossoms in the background, a Caucasian woman looks seductively out at the viewer, wearing only a kimono that falls open at the center front. In comparison, the rather staid portrait by Pierre-Auguste Renoir (1841–1919) of a seated Madame Hériot from 1882 depicts the sitter wearing a kimono over a stylish day dress (p. 49, fig. 2). While both paintings illustrate in detail a carefully crafted, high-end kimono, each transmutes this formal attire, suitable for a wealthy Japanese woman of the military class, into an exotic—and in Tissot's case, erotic—ancillary garment.[11]

At the same time these artists were presenting Japanese dress as voluminous and unrestrained, there were movements afoot in both Britain and the United States endorsing less constrictive garments for women. From the mid-nineteenth to the early twentieth century, proponents of dress reform promoted, designed, and wore more practical fashion, arguing that their constructions were more healthful and beautiful than prevailing modes. In the 1870s the tea gown came to prominence in Europe and America, also affording a measure of emancipation to women. These sophisticated interior gowns, recommended for afternoon entertaining, were often less structured than other garments—bereft of boning in the bodice, for example—but few women wore them as prescribed: without a corset.[12] Another voice advocating dress reform in the late nineteenth century was Arthur Lasenby Liberty (1843–1917), who founded Liberty & Co. in 1875 and specialized in importing silk from Asia. Established in 1884, Liberty's costume department took as inspiration historic garb from all periods, with its wide-sleeved at-home gowns and outerwear of the early twentieth century incorporating elements of Japanese dress.[13]

Although Western women's fashionable dress of the 1890s was stiff and constrictive, at-home garments adopted more comfortable forms. In 1893 *Harper's Bazaar* published an advertisement for "Japanese Kimono or Native Dresses" to be worn as tea gowns or morning wrappers, accessorized with an "embroidered and fringed obi or sash," made especially for the New York–based A. A. Vantine & Co.[14] Advertisements and fashion articles featuring kimono-inspired wrappers, bathrobes, tea gowns, dressing gowns, or invalid wraps similar in cut to the traditional kimono for both men and women appeared in many periodicals. In 1896 *The Maine Farmer and Journal of the Useful Arts* published an article titled "The Kimono and How to Make It." The piece described the garment's advantages, stating, "It is comfortable beyond compare to slip on, over the nightdress if necessary. . . . It is chic looking . . . and if you are ever the owner of one of these kimonos you will come to regard life as a failure without one or more always in stock."[15] Clearly, by the mid-1890s even a woman in rural Maine might be convinced that a kimono was a useful and fashionable garment that one should never be without. Similarly, the *Harper's Bazaar* reader, who perhaps could not afford to purchase a ready-made kimono-styled dressing gown, was catered to with tissue-paper sewing patterns that could be ordered through the magazine. Described as "distinctly suggestive of home comfort" and "a recognized and deserved favorite of womankind," the kimono was generally approved of as a comfortable necessity in a woman's wardrobe.[16] As the new century progressed, these relaxed forms of dress were progressively modified, veering away from the traditional kimono form, and adapted to fashionable trends. Short jackets with lapels, shaped sleeves with turned-back cuffs and gathering at the shoulders, fronts and backs gathered to dropped yokes, and full-length gowns with bell sleeves and lace trim were all called kimono.[17] As in the Dutch *rocken* or Tissot's and Renoir's paintings, the Westernized "kimono" was transmogrified into a garment that had only a minimal connection with its original form.

A Personal Look

The exotic nature of kimono still held cachet in the 1920s, when fashionable dress had advanced to looser and more comfortable styles. For example, the American Alice Jones Page (1861–1931) probably purchased her kimono in the early 1920s when she traveled to Europe and Asia, including Japan (fig. 1).[18] Woven in silk crepe with a black-on-black damask floral design, it is lined with bright yellow silk and embroidered using twisted silk thread. At first glance this garment appears similar in cut to the conventional form, but upon closer inspection Page's kimono reveals several modifications. Japanese kimono were customarily constructed from narrow lengths of silk, necessitating a center back seam. Here, the back is a single width of cloth, the total length is shortened, and it is accessorized with a soft fringed sash that simulates the obi when wrapped around the waist. The skirt is widened with godets set in the side seams, allowing for a wider stride. Most striking is the employment of the American Beauty–style

roses embroidered on this fundamentally traditional Japanese form—an example of the intersection of East-West aesthetics. It is clear that the makers sought to appeal to Western sensibilities with this design, and Page responded to the enticement.[19]

Like quilted dressing gowns from the 1870s, kimono such as these, manufactured in the early twentieth century, were exported from Yokohama. Alice Page's unlabeled kimono was probably purchased on her Asian travels, but it must be noted that by 1910 similar items were flooding the American market from European manufacturers and were available for purchase from outlets such as the Oriental Store at Vantine's or Elizabeth Allen's establishment in New York (fig. 2).[20] Further, in 1910 Page's daughter Ethel (1882–1976) married William Leo Doepke (1883–1934), heir to the massive Alms & Doepke Dry Goods Company. Like many concerns of its type, this Cincinnati retailer imported items from Asia, and various styles of kimono were featured in its advertisements from the early twentieth century.[21]

A kimono originally owned by Ella Stimson Cate (1865–1938) offers another specific example of Western interest in Japanese dress. Born in Massachusetts, Stimson was courted by (Isaac) Wallace Cate (1862–1908), an ordained minister who from 1890 to 1897 lived in Japan, where he served the Universalist Japanese Mission. Ella joined Wallace in Japan in 1891, where they were married and raised their family. Wallace died in 1908, and Ella eventually returned to the United States after a round-the-world tour in 1928.

Although the trend was on the wane by the late 1920s, middle-class women were encouraged by decorating periodicals to create "cozy corners" in their homes. These intimate spaces were used to display a variety of decorative items from other cultures, sometimes mixing Turkish brass with posters from Paris and Japanese textiles.[22] Exposed to these foreign aesthetics at the opera and the theater, in novels and in art galleries, and at international expositions, women used the cozy corner as a testament to their artistic acumen and knowledge of worlds beyond their own. Perhaps hoping to profit by this interest in exotica, and with established connections in the East, Ella and her son (Philip) Harding Cate (1902–1997) opened the Oriental Shop in Nashua, New Hampshire, in the late 1920s, through which they imported and sold Asian merchandise.

As early as September 1926, while still living in Japan, Ella seems to have been acting as a wholesaler of Asian goods for various small curio shops in the United States. A 1927 letter from Ella's daughter Esther (1892–1982) mentions Mary Canfield (1864–1946), proprietor of the Woodstock Craft Shop in Vermont, who informed her that "the goods have arrived and all are 'nice things.'" Esther went on to discuss starting a business with her mother—selling Asian objects and providing interior decorating services—once Ella returned home. Later that year, Esther related that Mrs. Canfield could sell "the bright colored

Fig. 2
Advertisement for Elizabeth Allen (Elizabeth Arden Co.), *Vogue* 45, no. 7 (April 1, 1915): 122.

Fig. 3
Kimono and Sash, approx. 1920. Japan, Taishō period (1912–1926). Silk crepe. *Newark Museum Purchase 1929* 29.3A,B.

silk kimonos" quickly, listing pongee dresses, combs, leather and silk card cases, lacquer boxes, and pearls as other items that were being wholesaled to concerns in the area.

By February 1928 Ella began to ship merchandise to Nashua in earnest for her own shop. Lengths of silk crepe dress fabrics are listed on invoices from N. Yamamoto Shoten in Yokohama, followed by cotton crepe kimono, silk crepe scarves, brocaded *happi* coats, and ladies' pajamas from an exporter in Kobe. At the same time, the Cates were also corresponding with wholesalers based in Massachusetts, New York, and Ohio, ordering a wide variety of Asian-style products such as brass gongs and incense burners, calendars, letter openers, and travel kits. Although the Cates were hopeful for their venture based on the success of Canfield and others, financial ledgers indicate the shop struggled from the start and closed in 1929.[23]

A bright red kimono made in Japan for the Western market—perhaps a survivor of the Oriental Shop or to be worn by Cate herself—can be found in the collection of the Newark Museum, which acquired it from Ella Cate's daughter-in-law (fig. 3). Constructed much like Alice Page's kimono but without side godets, this piece is decorated with a variety of flowers and butterflies and accessorized with a similar narrow sash.

Conclusion

Worn in the traditional manner, the kimono could be a confining form of dress. Formal modes stipulated multiple layers, a constricting obi wrapped and tied around the waist, and a limited circumference at the hem, all of which restricted mobility. However, its simple wrap construction from wide expanses of fabric that draped on the body stood in stark contrast to nineteenth-century bespoke, structured, and boned Parisian-designed fashionable dress. Westerners adopted the form without such circumscriptions, utilizing the kimono as a loose and voluminous garment worn over their own constricting dress. From the seventeenth to the early twentieth century, the kimono was transformed into a relaxed garment. It was fitted to Western tastes with minimal variations—such as godets set in the side seams of a traditional form—to the appropriation of a single element, such as commodious sleeves, applied to a fashionable Parisian creation. The enthusiasm for kimono exhibited by both Ella Cate and Alice Page was part of a larger movement in the West that fed an interest in Japanese aesthetics, specifically, and exotica, in general. Whatever modified shape it took, the kimono engaged women on all social levels, propelling fashionable Western dress—and therefore those who wore it—forward. Women of the late nineteenth and early twentieth centuries used the incorporation of kimono into their wardrobes as a means to free themselves from constrictions and to assert their awareness of the wider world.

Katherine Anne Paul

OCCIDENTALISMS IN JAPANESE FASHION

Fascination with the foreign—materials, colors, techniques, forms, etc.—is a consistent theme across time and place. Often discussed as a single vector, such influences are always multidirectional, affecting all who make contact with them on some level. While academic explorations of Japonism, chinoiserie, and Orientalism have circulated for more than two centuries, visual studies of Occidentalism—things "Western"—should play a larger role in the art historical discourse. Historically, for Japan, the "West" encompassed all non–East Asian regions. The Japanese have viewed Southeast, South, and West Asia as "Western" as Europe and the Americas. For the purpose of this essay, "Occidentalism" is defined as an amalgamation of actual things from the "West" as well as impressions of things "Western" ranging from as near to Japan as Southeast Asia and South Asia to as distant as Europe and the Americas. This reading of Occidentalism serves as a corollary to Orientalism where—in fashion in particular—both "isms" produce a mélange of intended fantasies about an "other." Occidentalism—like Japonism, chinoiserie, and Orientalism—constantly evolved through dynamic intercultural encounters on many levels over the centuries. Iterative forms of Occidentalism began surprisingly early—centuries before Japonism became apparent in the West—and should not be conflated with globalism (phenomena that are found globally in the same time frame). This essay provides a brief chronological discussion of Occidentalisms in Japanese fashion, examining a selection of materials (fibers and dyestuffs), techniques (weaving and dyeing), forms (tailoring), artistic motifs (surface decoration), and modes of transmission (physical travel, printed materials, and motion pictures). Moreover, it distinguishes later iterations of Occidentalism from globalism. This discussion highlights signature objects featured in this catalogue and works held in the Newark Museum's historic collection of Japanese art, begun in 1909.

Premodern Precedents (200s–1500s)

Early Japanese history of dress indicates that many items contemporary consumers identify as "Japanese" were themselves earlier imports. Silk production arrived in Japan from continental Asia (present-day China and/or Korea) in the third century. In the sixth century Buddhism (originating in South Asia) was promoted as Japan's state religion. Monastic and ritual clothing inherent to Buddhist practice was adopted, and imagery based on an iconographic language forged in central and southern Asia and then filtered through Chinese and Korean interlocutors entered Japanese visual vocabularies.[1] Additional relevant

technology transfers from China and Korea at that time included the Chinese writing system to record the Japanese language as well as paper making and printing, which arrived centuries before similar technologies developed in Europe. During Japan's Muromachi period (1392–1573), cotton—both as raw material and as finished cloth—was a valued import from China and Korea.[2]

Southern Barbarians: *Nanban* in Japanese Fashion (1500s–1700s)

The Portuguese arrival in 1543, and the subsequent introduction of Christianity catalyzed a wave of Occidentalisms in the fashions of the Momoyama period (1573–1615) analogous to the earlier introduction of Buddhism.[3] This wave of Occidentalism brought Japan European Renaissance clothing styles along with Western drawing and painting techniques, including color palette choices and forced perspective. Japanese garments of the Momoyama and Edo (1615–1868) periods tailored from imported Occidental cloth survive today in collections around the world (as do paintings of individuals wearing garments made from these fabrics). More rarely, a number of Occidentalist folding screens survive in Japanese, Portuguese, and Mexican collections.[4] The term *nanban* (southern barbarian) denoted both European and Southeast Asian merchant traders and remains a term affiliated with porcelain and lacquer export wares sent from Japan to Europe. There were also *nanban* fashion trends in Japan.

Called *sarasa* in Japanese and on trade lists, printed and resist-dyed cotton and silk finished fabrics produced in Southeast and South Asia were imported to Japan through Portuguese, Spanish, English, Dutch, Chinese, and Japanese traders.[5] Many *sarasa* survive as wrappers for treasured tea ceremony implements or as fashion accessories like tobacco pouches and pipe cases.[6] Finished woolen cloths, imported by the Portuguese, Spanish, and Dutch from the late sixteenth century, were another prized novelty. Later, Edo-period Japanese military vests (*jinbaori*) were not only made from imported woolens and other Occidental materials but also modeled on European silhouettes.[7]

With the rise of the Tokugawa shogunate in the Edo period, Christianity was outlawed and violently suppressed. Furthermore, from 1643 sumptuary laws regulated approved styles and materials of clothing for each social class. After 1639 the government implemented isolationist policies and granted the Dutch a monopoly that remained in effect until 1854. Because Occidental trade remained sanctioned with the nonproselytizing Dutch, images of Dutchmen became a decorative fashion. For example, images of Dutchmen wearing eighteenth-century dress are found on imported printed cottons and on Japanese-made woven silks, as in the pattern here titled *Nanban Drinking* (fig. 1).[8] Newark's collection retains a number of portraits of Chinese and Dutch

Fig. 1
Nanban Drinking. Japan, Edo period (1615–1868). Silk twill weave with gold brocade; H. 36.2 cm x W. 29.2 cm. *Newark Museum, Newark, NJ, Gift of Herman A. E. Jaehne and Paul C. Jaehne, 1941* 41.1268.

men as netsuke toggles, a fashion accessory that skirted the sumptuary laws dictating appropriate luxury "hanging ornaments" (*sagemono*) for each class.[9]

Edo-period Occidentalisms in Japanese dress usually manifested in one of three ways: first, as Western fabrics tailored to suit Japanese consumers; second, introduced as motifs on Japanese-produced fabrics (see fig. 1); third, featured as accessories that provided foreign accents to distinguish, without overly differentiating, oneself from one's community. This iteration paralleled the later progress of Japonism as illustrated in this catalogue by Japanese fabrics tailored to Occidental silhouettes, as in the dress from Misses Turner Court Dress Makers (cat. 4), or French-produced cloth with Japanese motifs, as in the ball gown by House of Rouff (cat. 6), the visite from around 1890 (cat. 7), and the brocade by Béraud & Cie (cat. 9).

Meiji and Modernization (1868–1912)

Isolationist policies imposed during the Edo period were reversed in the Meiji period (1868–1912). Instead of restricting outside contact, the government funded participation in a number of international expositions that promoted newly developed technologies and provided widespread access to international markets. Japanese participation in the London (1862), Paris (1867, 1878, 1889), Vienna (1873), Philadelphia (1876), Chicago (1893), and St. Louis (1904) expositions facilitated the export of Japanese goods into the wider world and provided access for Occidentalisms to enter Japan.

New raw materials and technologies were introduced and rapidly adapted to Japanese fashions. Aniline chemical dyes (invented in Germany in 1856) quickly colored kimono (p. 15, fig. 3). This technology was so valued that in 1875 the Meiji government established the Japanese Chemistry Bureau to develop new synthetic dyes, among other chemicals. Both the Jacquard loom and Kaye's flying shuttle were imported to Japan following the 1873 Vienna exposition. Advances in mechanizing textile production had a profound effect in Japan (as they did in the West), including on the labor force.[10] Thus the Industrial Revolution flourished in Japan, expanding a diversity of professions, creating new domestic markets, and facilitating greater volumes of Occidental imports while increasing Japanese exports to the West.

The sumptuary laws that governed dress codes also were drastically altered during the Meiji period. Beginning in 1870, government workers were required to wear Western dress on the job. In 1871 regular postal service in Japan began, extending the circulation of fashion through domestic and international mail orders—both for printed materials about clothing and for actual clothing. In 1872 the first railroads were constructed. Individuals in many newly established professions (postal

carriers, railroad workers, policemen, etc.) were required to don Western-style clothes when working. As most government workers were male, the clothing was heavily influenced by military and civil service uniforms in the European tradition. In the upper echelons of society, too, men and women were mandated to wear Western dress at Japanese court functions.[11]

Because Occidental dress was encouraged, a new vocabulary describing appropriate Western wear was created. The somewhat derogatory term *nanban* as an Occidental descriptor was discarded during the Meiji period and the more neutral term *yōfuku*, meaning "Western-style clothing," was coined and juxtaposed with *wafuku*, or "Japanese-style clothing." Additionally, the term *kimono*—an abbreviation of *kirumono* (meaning a "thing to wear")—became a prominent catch-all term in this period, both within Japan and abroad. For men's and women's dress it was the cut and tailoring of the cloth more than the surface decoration that made a garment *yōfuku*. For example, Newark's quilted *yōfuku* dressing gown (fig. 2) features crimson frogs, a fitted waist, and a full-cut skirt with a train to cover a small bustle. The collar, cuffs, pockets, the back of the bodice, and the full front are embroidered with flowers of Japanese varieties (rather than Occidental flowers that might appear on other garments).[12] Every element of this dress—excepting the choice of flowers and the processing of the silk fabric—is Occidental. Surviving garments such as Newark's gown often are discussed solely as made for export. However, the museum's records reveal this gown was purchased in Yokohama in 1883, meaning it was available to Japanese consumers as well as foreign buyers.[13]

The same year Newark's gown was purchased, the Rokumeikan era (1883–1899) began. This period was named after a Western-style building where Occidentalist dress and other Western-style social niceties—such as eating Western foods with Western utensils while seated upon Western furniture as well as dancing and meeting—took place. The Rokumeikan housed foreign guests and was intended as a showcase. Prior to the building of the Imperial Hotel (1890), it was where Occidental social forms (prevalent in the dominating global industrial economies of the period) could be performed.[14] A number of surviving Japanese prints depicting events at the Rokumeikan feature elegant Japanese ladies wearing garments with silhouettes like those made by Misses Turner Court Dress Makers, House of Rouff, and other Paris designers (cats. 4, 6, and 7).[15] Also evident in these prints are children dressed in *yōfuku*—both as school uniforms and as activewear.[16]

As *yōfuku* became implicitly or explicitly required, new avenues of fashion developed. Department stores made their debut in Japan with Mitsukoshi in 1904 and quickly blossomed.[17] Like similar stores that were developing around the world in this time frame, they sold a wide range of domestic and imported items. Unlike their Occidental counterparts, however, whole floors were designated for the sale of

yōfuku, while other floors continued to sell *wafuku*. The latter were not traditional kimono; instead they were new styles of kimono that featured Occidentalist, globalist, and Japonesque decorative motifs and employed innovative materials, weaving, and dying techniques.[18] Department stores aggressively advertised their goods in new print media that disseminated visual culture more rapidly and widely than ever before. People also moved farther afield, as significant Japanese immigration to both North and South America during the Meiji period began to create global communities and a Japanese diaspora—further connecting Japan to the West.[19]

Taishō and Transition (1912–1926); Early Shōwa (1926–1945) and the Shrinking Globe

The brief years of the Taishō period (1912–1926) saw additional advances in manufacturing, transportation, and communication—and, with it, a number of social revolutions. As in the West, Japanese women took on many new professional roles (such as bus conductors, nurses, typists, and waitresses in Western-style eateries). These professions required a new dress code—one concurrent with flappers around the world sporting shorter everything, from hemlines to hairdos. The evening coats by House of Amy Linker (cat. 14) and Chanel (cat. 16) and Madeleine Vionnet's "Henriette" evening dress (cat. 18) would be at home among chic Taishō-era Japanese.[20]

European-style cafés were established in Japan and became the trendy meeting place of *moga* (modern girls) and *mobo* (modern boys)—the bright young things of Taishō. As elsewhere, motion pictures and women's magazines provided new delivery mechanisms for consumer culture.[21] Japan was an active inventor and maker of these modernities: Japan's first animated film premiered in 1916; the Mitsubishi Model A—the first domestically produced car—arrived in 1917, the same year Nikon was founded; and Panasonic began in 1918. The heads of these and many other companies were the nouveau riche of the 1920s and wholly engaged with internationalism. Neither Occidentalist nor Orientalist, they were the trendsetters and top Japanese enactors of an ever more interconnected globalism.

Rayon was invented in the mid-nineteenth century in Europe, and slightly different proprietary chemical recipes for this synthetic fiber allowed for numerous distinctive producers. In Shōwa-period Japan (1926–1989), Shinkō Rayon Ltd. (controlled by Mitsubishi) began mass production in 1933, and by 1937 it dominated the market. It is the fabric of Newark's "Mickey Mouse" *juban* underrobe (fig. 3). While the cut of this garment is quintessentially Japanese, the checked patterns, color choices, and compositional elements reflect global variations of the international Art Deco movement—elements that are *not* purely

Fig. 2
Quilted Robe with Floral Motifs, approx. 1880–1883. Japan, Meiji period (1868–1912), for domestic and international markets. Silk with silk embroidery. *Newark Museum, Newark, NJ, Gift of William W. Woodward III, 1943* 43.212A,B.

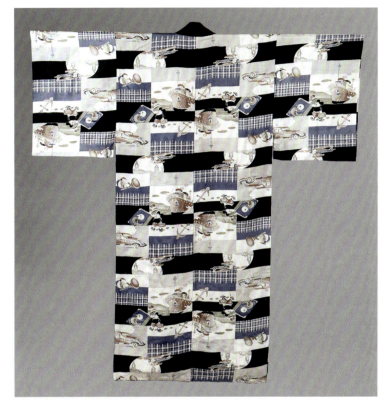

Occidental.[22] The single Occidental element on this robe is Mickey Mouse (created in 1928), who raises his top hat and carries a radio inscribed with the letters "KW" (for kilowatt). The stately luxury liners, soaring airplanes, sleek automobiles, and modern cityscapes surrounding Mickey are not Occidentalist because Japan was producing all of these items during the same period of time; thus, these motifs are actually globalisms of the period.

Recall that I have defined globalism as phenomena that are found globally in the same time frame. (This is consciously differentiated from modernisms that have wider temporal disparities as different regions modernize at different rates.) The production of automobiles, cameras, rayon fabrics, and other items flourished within Japan for Japanese consumers (as well as for export) just as those items were made in the West in the same time frame. Thus, from the Taishō period to the present day, globalisms—along with Occidentalisms and Japonisms—have enlivened fashion and other arenas of Japanese design. These iterative waves of Occidentalism—Buddhist, *nanban*, *yōfuku*, and globalist—reveal rich aesthetic and technical interactions at play in Japanese fashion. These exchanges continue to inspire the twentieth- and twenty-first-century fashions so beautifully showcased in this catalogue.

Karin G. Oen

The Japanese Avant-Garde in Global Fashion

In the early 1980s several Japanese fashion designers broke into the world of Parisian high fashion with shocking collections that veered away from traditional garment construction, especially fine finishing. Many of the looks presented by Rei Kawakubo (b. 1942), Issey Miyake (b. 1938), and Yohji Yamamoto (b. 1943) featured asymmetry and exposed seams and appeared to be either partly finished, unfinished, or undone. These collections were not the designers' debuts, as each had established their brands in Tokyo in the 1970s, but their presentations in Paris signaled a declaration that this work had a place in the capital of global fashion.

It was not the first time that Parisian runways had seen the work of Japanese designers: Hanae Mori (b. 1926), Kenzō Takada (b. 1939), and Kansai Yamamoto (b. 1944) had shown in Paris in the 1970s. Their overall aesthetic reflected a harmonious incorporation of Japanese design elements—layering, wide sleeves, loose fit—with Western garment construction. Their collections had been notable but didn't cause a major disruption.

Kawakubo, Miyake, and Yamamoto showed garments that were altogether different, signaling a break with the standards of beauty in haute couture and forging a new territory dubbed "Japanese avant-garde fashion."[1] The "avant-garde" portion of this label is arguably more significant than the identifier "Japanese," but both modifiers were necessary to understand the movement and its reception in the West as an extension of the productive fascination with Japanese art and design that was a major part of modern art history. The collections were correctly seen as infused with Japanese aesthetics and design principles, both traditional and postwar. The cultural and visual vocabulary of Japan was present in these collections (albeit in nontraditional form) and sparked among global fashionistas a sort of updated, diffuse Japonism. The revolutionary importance of these designers lies not in a particular style or technique but in a deconstructionist approach that would allow them to innovate and, in the words of Kawakubo, "to do things that [had] never been done before."[2]

Deconstructing *Le Destroy*

In fashion journalism, this presumed antifashion phenomenon was described by a variety of unflattering terms, including "ragged chic" and "beggar look."[3] More sophisticated readings saw these fashions as examples of philosophical deconstruction in practice. The aesthetic was called *la mode destroy* (destruction fashion) or simply *le destroy*—a variation on the term "deconstruction" and, in German, *destruktion*, a word

that featured prominently in the work of Martin Heidegger (1889–1976), most notably in his 1927 work *Being and Time*, a seminal critique of Cartesian metaphysics and Western philosophy in general. More recently, starting in the 1960s, the French philosopher Jacques Derrida (1930–2004) expanded on Heidegger's critique by enlarging the territory explored with the concept of deconstruction. As framed by Derrida in *Of Grammatology* (1967), deconstruction is the never-ending activity of investigating the social, political, linguistic, and cultural structures that underpin the texts, images, objects, etc., that populate our world, resulting in multiple and sometimes conflicting interpretations. Derrida himself resisted defining deconstruction as a clear-cut methodology, analysis, or critique, but in a 1988 interview he stated, "Deconstruction goes through certain social and political structures, meeting with resistance and displacing institutions as it does so."[4]

The concept and practice of deconstruction easily crossed over from philosophy into such realms as cinema, architecture, linguistics, and literature. Deconstruction's role in the world of fashion—and the attendant resistance, disruption, and displacement that went along with it—are in many ways to be expected. The modern, postmodern, and poststructuralist trends in art and design throughout the twentieth century were directly or indirectly informed by the *destruktion* of Heidegger and the deconstruction of Derrida. In fashion, deconstruction was never wholly the territory of Kawakubo, Miyake, and Yamamoto. Martin Margiela (b. 1957), Ann Demeulemeester (b. 1959), and Dries Van Noten (b. 1958) were among the European designers to contribute to this disruptive approach to high fashion. That being said, the work of these Japanese designers and the role their collections played in upending contemporary fashion sensibilities are particularly important. They struck a cultural chord because of their perceived otherness: the clothing was different enough to be interesting when paired with its similarity in spirit and concept to the deconstructive practices already at work in postwar Europe.

Dismantling Deconstruction in Translation

At the same time Japanese fashion designers were redefining contemporary fashion in Paris, Derrida was considering Japan. In his 1983 "Letter to a Japanese Friend,"[5] Derrida reflected upon his particular use of the term deconstruction in order to help with its translation into Japanese:

> To be very schematic I would say that the difficulty of defining and therefore also of translating the word "deconstruction" stems from the fact that all the predicates, all the defining concepts, all the lexical significations, and even the syntactic articulations, which seem at one moment to lend themselves to this definition or to that translation, are also deconstructed or deconstructible, directly or otherwise,

Fig. 1
Comme des Garçons Autumn/ Winter 1982 fashion show, Paris.

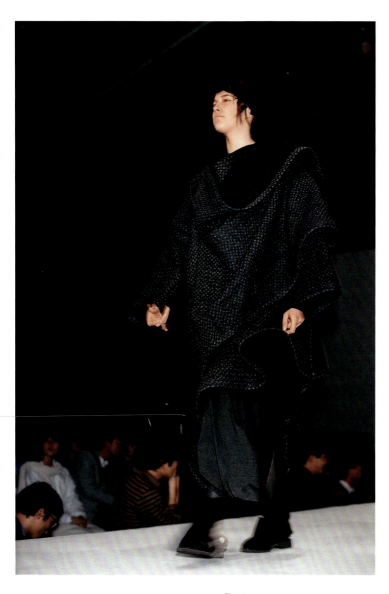

Fig. 2
Comme des Garçons Autumn/
Winter 1984 fashion show, Paris.

etc. . . . All the same, and in spite of appearances, deconstruction is neither an analysis nor a critique and its translation would have to take that into consideration. It is not an analysis in particular because the dismantling of a structure is not a regression toward a simple element, toward an indissoluble origin.[6]

Thus, per Derrida, deconstruction is no one thing, and its relevance extends beyond any particular cultural sphere. It is a concept and activity defined by its fugitive nature and its multiplicity; as a result, it was difficult to translate because it was difficult to sum up neatly. The ready adaptation of this complex term to the designs of Kawakubo, Miyake, and Yamamoto since the 1980s speaks in part to the way the garments were composed and assembled (or decomposed and disassembled). It also acknowledges the cosmopolitan nature of art and design during the modern and contemporary eras, and the selective incorporation of concepts, visual elements, and techniques from multiple cultural sources.

Japonism as Creative Disruption

The austere and imperfect look put forward by Kawakubo, Miyake, and Yamamoto was starkly different in form from the identifiably Japanese kimono, prints, and decorative objects that had been incorporated into the parlors of fashionable Parisian literary and art circles a century earlier. As the garments and works of art in this exhibition suggest, elements from kimono and other icons of Japanese design have flourished in Western fashion since the nineteenth century. This reflects a productive cultural cross-pollination but also highlights the complexity of influence and exchange and the long history of deconstruction as a mode of creative disruption. The garments chosen for this exhibition encompass a broad set of interpretations of the kimono that represent an ongoing engagement with the art and design of Japan. They function not as a set of visual sutures between radically different costume traditions but as a selection that manifests the deconstruction and reconstruction of culture and form throughout the modern era. This presages Derrida's articulation of deconstruction in the 1960s—and the fashion world's declaration that the innovative collections from Japanese designers in the 1980s could be described as *le destroy*. The kimono and its design elements have intersected with, upended, and disrupted Paris fashion for decades, in some cases subtly and beautifully, and in others with the creative power of destruction.

JAPONISM IN ART AND FASHION

For much of its history, Japan and its cultural riches were hidden from the Western world. Strict trade policies and self-imposed isolation meant that few examples of Japanese artworks and textiles made their way to Europe. It was not until the late 1850s that Japan officially reopened its ports to international trade, and from then on, a myriad of Japanese products reached Western shores.[1] Many artists and clothing designers were captivated and inspired by the Japanese motifs, patterns, and techniques, which they encountered for the first time. These new sources transformed their works beyond the traditional bounds of European art and fashion of the time. This embrace of Japanese aesthetics and the resulting explosion of new creative expression in Western art and fashion came to be known as "Japonism."

Japan's Impact on Western Painting

Japonism emerged in both Western art and fashion.[2] As Japanese artworks began to spread through Europe, many painters employed "exotic" objects such as fans, kimono, and woodblock prints (ukiyo-e) as props. In *Young Women Looking at Japanese Articles* (1869; cat. 1), the French artist Jacques-Joseph James Tissot (1836–1902) painted two women looking closely at a model of a Japanese boat. The Japanese items in this painting are treated as foreign and out of context: a lavishly embroidered kimono is repurposed as drapery, while Japanese dolls are incongruously exhibited in an ornate black-lacquered Buddhist altar. In 1876 the French Impressionist painter Claude Monet (1840–1926), who collected more than 200 Japanese prints, captured his wife, Camille, posing in an elaborate red *uchikake*, or padded outer robe, with a design of a mustached samurai-like figure unsheathing his sword (fig. 1). Camille holds a Japanese folding fan and stands before a wall decorated with many round Japanese fans.

In the early stages of Japonism, artists were simply depicting beautiful foreign objects and imitating Japanese woodblock prints. The Dutch artist Vincent van Gogh (1853–1890), another avid collector of ukiyo-e, modeled several of his paintings on such prints, an example being *Courtesan* (fig. 2), which he based on a print by Keisai Eisen (1790–1848) that in 1886 had been reproduced on the cover of the magazine *Paris Illustré* (*Paris Illustrated*; p. 63, fig. 1).[3] Van Gogh created a frame around his subject, filling it with Japanese-inspired motifs—a pond with water lilies, bamboo, cranes, and frogs—that added hidden meanings alluding to the central figure (the French words for "crane" and "frog" were common slang for prostitutes at that time).

Following the initial contact with Japanese objects, Western artists moved away from direct copying and began to analyze Japanese artistic principles. Many of the techniques taken up by these artists can be

Fig. 1
Camille Monet in Japanese Costume, 1876. By Claude Monet (French, 1840–1926). Oil on canvas; H. 231.8 cm x W. 142.3 cm. Museum of Fine Arts, Boston, *1951 Purchase Fund*, 56.147.

Fig. 2
Courtesan (after Eisen), 1887. By Vincent van Gogh (Dutch, 1853–1890). Oil on canvas; H. 100.7 cm x W. 60.7 cm. Van Gogh Museum, Amsterdam, s0116V1962.

seen in *Mannen Bridge, Fukagawa* (fig. 3) by the Japanese printmaker Utagawa Hiroshige (1797–1858). He achieved surprising contrast and an interesting viewpoint with the juxtaposition of a turtle hanging from a rope in the foreground and a small, distant Mount Fuji in the background. The handle and basin of a wooden bucket, almost completely cropped out of the picture, and the edge of the window have been employed to subtly frame the scene. Below the turtle, glimpses of a boat and a man wearing a straw hat with a pole in hand suggest that the figure is a boatman steering with an oar. The bold contour lines, novel style, and exciting compositional techniques used in this print were rarely seen in Western paintings before the late nineteenth century.

Western artists began applying unusual viewpoints, asymmetric compositions, extreme foreground close-ups, flatness created by bold outlines and colors, and radically cropped objects to create something new in their art. For example, the French artist Henri de Toulouse-Lautrec (1864–1901) frequently incorporated Japanese compositional techniques. In his 1892–1893 lithograph *Divan Japonais* (fig. 4), Lautrec depicted Jane Avril (1868–1943) watching fellow actress Yvette Guilbert (1865–1944) performing on stage at Divan Japonais, a café-concert in Paris. The presence of the orchestra is implied by the arms of the conductor and the tops of string instruments. Although the artist cropped Guilbert's head out of the frame, fans would have recognized the performer by her trademark long black gloves. There is no Japanese object or motif present in this poster, yet the impact of Japonism can be felt through Lautrec's dramatic composition, unusual viewpoint, bold outlines, and flattened forms.

Late-nineteenth-century Western art critics were excited about these fresh ideas and commented on the compositional approaches commonly found in Japanese prints. In an 1878 essay, French art historian and critic Ernest Chesneau (1833–1890) remarked on "the unexpected compositions, the science of form, the richness of tone, the originality of picturesque effect"[4] in Japanese art. In 1898 the French critic Louis Gonse (1846–1921) commented on Japanese art's "bold and unprecedented way of framing a composition" and how earlier European artists would not have thought to use the boundaries of the canvas to "cut off the subject of a painting as they do today."[5] Around the same time, the German art historian Richard Muther (1860–1909) noted Japanese artists' ability to suggest "the whole by a part" and their "manner of giving the impression of the object without the need for the whole of it being executed."[6] This represented a break with traditional European oil painting, where each canvas usually represents a completely independent and self-contained scene. The aesthetic of the fragment to suggest what is beyond the edges of the canvas was a revelation to European critics.

Artists were as enthusiastic about the Japanese aesthetic as the critics. Van Gogh expressed his passion in an 1888 letter, saying, "All my

Fig. 3
Mannen Bridge, Fukagawa (Fukagawa Mannenbashi), no. 56 from One Hundred Famous Views of Edo, 11th month of 1857. By Utagawa Hiroshige (Japanese, 1797–1858). Woodblock print; ink and colors on paper; H. 36.2 cm x W. 23.6 cm. Brooklyn Museum, *Gift of Anna Ferris*, 30.1478.56.

work is based to some extent on Japanese art."[7] The American painter Arthur Wesley Dow (1857–1922) wrote in a 1890 letter: "One evening with Hokusai gave me more light on composition and decorative effect than years of study of pictures. I surely ought to compose in an entirely different manner."[8] In a conversation with a critic in 1909, Monet stated, "If you insist on forcing me into an affiliation with anyone else . . . then compare me with the old Japanese masters; their exquisite taste has always delighted me, and I like the suggestive quality of their aesthetic, which evokes presence by a shadow and the whole by the part."[9]

Japonism in International Fashion

In the same way artists adopted motifs, principles, and techniques from Japanese art, fashion designers learned from newly introduced Japanese models. The process was similar, but Japonism in fashion evolved more gradually at the turn of the twentieth century. Considered exotic garments, kimono imported from Japan were first used as dressing gowns. Some kimono made of beautiful textiles were taken apart and remade into Western dresses, as exemplified by the dress by Misses Turner Court Dress Makers (cat. 4). Like the painters, Western clothing designers imitated Japanese motifs as their initial way of incorporating those elements into their works. An anonymous fashion designer, for example, employed appliqués of embroidered fabrics with samurai-helmet (*kabuto*) and cherry-blossom motifs on a visite from around 1890 (cat. 7). In addition to using Japanese motifs, the designers of this time created kimono-shaped garments. A dress from the 1920s by French designer Paul Poiret (1879–1944), who was first inspired by kimono in the early 1900s, exemplifies this new form, incorporating details such as kimono sleeves, an obi-like belt, and overlapping kimono closures (cat. 15).

Designers eventually grasped the core principles of kimono design and moved away from mere imitation. They particularly responded to the flat, T-shaped structure of the kimono, which creates a simple, straight-lined silhouette without decorations such as frills, lace, ribbons, and tassels. Designers also focused on the fabrics of the kimono in order to create original outfits. In 1923 Madeleine Vionnet (1876–1975), an influential French fashion designer and collector of Japanese woodblock prints, pioneered a loose-fitting look that departed from the restrictive, corset-board silhouette common at the turn of the century (cat. 18).[10] She applied the flat construction of kimono to Western garments, which were traditionally tailored to fit individual body shapes. The pattern for the dress (p. 68, fig. 2) makes clear the linear cut of the garment, and the shimmering gold and silver textiles of this dress are reminiscent of the gold and silver leaves applied to Japanese folding screens (*byōbu*). These details acknowledge highly sophisticated craftsmanship as one of kimono's unique features.[11]

Fig. 4
Divan Japonais, 1892–1893.
By Henri de Toulouse-Lautrec
(French, 1864–1901). Colors
on offset lithographic print;
H. 80.8 cm x W. 60.8 cm.
Metropolitan Museum of Art,
Bequest of Clifford A. Furst, 1958
(MET) 58.621.17.

Since the 1920s the flat construction, shapes, motifs, and fabrics of kimono have inspired the creation of exciting new garments. Contemporary Japanese and Western fashion designers such as Issey Miyake (b. 1938; cats. 19–23), Rei Kawakubo (b. 1942; cats. 24, 30, 35, 40, and 41), John Galliano (b. 1960; cats. 26 and 36), and Sarah Burton (b. 1974; cat. 37) continue to incorporate kimono elements into their designs today. Miyake, in particular, went a step further with his 132 5. collection, applying an origami-like flat kimono construction to his multidimensional dresses. He explained that one (1) piece of cloth becomes a wearable three-dimensional (3) garment, and then is folded back into its two-dimensional (2) form. According to Miyake, the number five (5) in the title of this collection symbolizes "the temporal dimension that comes into being when the clothing is worn by people."[12] The principles of kimono have continued to stimulate not only Western but also Japanese contemporary fashion designers to create new garments.

Conclusion

The importance of cultural borrowing is acknowledged in a statement by Siegfried Bing (1838–1905), a German-French dealer of Japanese art and the publisher of the illustrated journal *Le Japon artistique* (*Artistic Japan*): "Unless we strengthen ourselves by a transfusion of fresh blood, how can we maintain our energy? And where is the civilized country—ancient or modern, far or near—that has not borrowed even a small bit of its artistic culture?"[13] As Bing noted, cultural borrowing has occurred in many places and times; still, Japonism in art and fashion was an exceptional phenomenon. It inspired many of the most famous Western artists and fashion designers to break away from tradition and take a different point of view, and it left a lasting mark on Western aesthetic and transformed the international world of art and fashion.

Rie Nii

WHY AN EXHIBITION ON KIMONO REFASHIONED?

The Kyoto Costume Institute and Kyoto Textile Culture

The Kyoto Costume Institute receives queries from time to time about kimono. As Kyoto is the ancient capital of Japan, where traditional culture continues to be transmitted today, the city is known worldwide for the kimono industry. It is thus understandable that people misunderstand the institute as a kimono research center. Each time we receive such an inquiry, we explain that the Kyoto Costume Institute is a research organization that collects, preserves, studies, and exhibits Western and modern Japanese fashion.

The institute was established in 1978 as the first organization in Japan with the foresight to recognize the necessity for a systematic study of Western fashion. Considering that everyday wear in Japan today was born in the West and that the country produces a large number of globally known fashion designers, the institute aims to detect future trends by increasing understanding of the essence of clothing and fashion.

That said, the Kyoto Costume Institute's activities are certainly not unrelated to kimono. It was established, after all, in Kyoto, where people understand perhaps better than anywhere else that kimono are an unparalleled pleasure in life—one that properly belongs in the field of art. As the saying "Kyoto people ruin themselves by extravagance in dress" suggests, many Kyoto dwellers love fine clothes, spending lavishly on their attire. Even after Edo (Tokyo) became the political and economic center in the seventeenth century, Kyoto remained a center of Japan's clothing culture. For that reason in particular, the establishment of a research institution devoted to Western garments as well as Kyoto's sartorial tradition was simply a natural development.

Activities of the Kyoto Costume Institute

Since its establishment, the Kyoto Costume Institute—which lacks a large exhibition space of its own—has focused its energy on building its collection and mounting exhibitions around the world that reflect the institute's unique place among museums. At present the collection includes approximately 13,000 garments and 20,000 documents covering Western clothing, undergarments, and accessories and related documentary material from the seventeenth century on. In particular, the institute has put energy into collecting pieces by Japanese designers, who after 1970 gained worldwide recognition: building on a 2,000-piece donation from Comme des Garçons, the institute has amassed works by Issey Miyake (b. 1938), Yohji Yamamoto (b. 1943), and younger designers. Until now, donations have come not just from Japan but also from leading Western brands, such as Yves Saint Laurent, Chanel, Christian Dior, Louis Vuitton, Calvin Klein, and Dries Van Noten.

Since large exhibitions are organized by the institute only every few years, additional undertakings publicizing the collection include publication of 500 selected works in *Fashion: A History from the 18th to 20th Century—The Collection of the Kyoto Costume Institute* (Taschen, 2002) and making available some 300 pieces online via the Google Arts & Culture site and on the institute's website.

Central to the activities of the Kyoto Costume Institute, however, are special exhibitions that fully exploit its peerless collection. Ever since the institute mounted its first large-scale exhibition in 1980—*Evolution in Fashion* (National Museum of Modern Art, Kyoto), featuring nineteenth-century fashion—it has received frequent invitations to assemble costume exhibitions at museums inside Japan and abroad, such as *Revolution in Fashion 1715–1815* (1989–1991, Musée des Arts de la Mode et du Textile au Louvre, Paris; Museum at the Fashion Institute of Technology, New York; and other venues), *Japonism in Fashion* (1994–2003, various venues; see below); *Fashion in Colors* (2004–2007, Cooper-Hewitt National Design Museum, New York, and other venues); and *Future Beauty* (2010–2015, various venues; see below).

Japonism in Fashion and *Future Beauty*

Japonism in Fashion established a pivotal research theme for the Kyoto Costume Institute that has led directly to the present exhibition. *Japonism in Fashion* explored the influence of kimono and Japanese culture as it appeared in European fashion beginning at the end of the nineteenth century (fig. 1). Until that time, the importance of fashion as an aspect of the impact of Japanese culture on the West had not yet been fully recognized. Around 1990 the institute's director, Akiko Fukai, began to broach the concept of the exhibition in talks with the curatorial staff. We proposed the hypothesis that the kimono influenced Western fashion in distinct stages: first, the kimono was repurposed as a dressing gown; then, its designs and silhouette were adopted into Western clothing design; and finally, in the 1920s, the cut and construction of the kimono became influential.

In 1994 the *Japonism in Fashion* exhibition opened at the National Museum of Modern Art, Kyoto. It included 150 works, many from the Kyoto Costume Institute collection along with pieces borrowed from museums in Paris and New York. Over the next ten years the show grew into a traveling exhibition that circulated to seven cities: it opened in 1996 at the Musée de la Mode et du Costume, Paris, and then appeared in 1998 in Tokyo and at the Los Angeles County Museum of Art and the Brooklyn Museum of Art; and in 2003 at the Museum of New Zealand Te Papa Tongarewa, Wellington.

In the second half of the 1990s, as this exhibition traveled to various venues, the influence of Japanese style began to emerge ever more strongly in contemporary fashion. For instance, in 1997 kimono

Fig. 1
Cover of the exhibition catalogue for *Japonism in Fashion*, Tokyo, 1996.

designs and forms appeared in offerings from famous brands such as Valentino, D&G, and Christian Dior, as well as in Givenchy's 1997 fall and winter haute couture collection, where the creative director, Alexander McQueen (1969–2010), offered a design with a Japanese helmet called *Kabutogara Visite*.[1]

At the same time a new and important interest in Japan grew as manga and anime began to influence the world's pop culture. Young people began to sport Nike sneakers shaped like split-toe socks (*tabi*) and flip-flops imitating the grass slippers (*zōri*) that appear in Japanese anime. This vogue crested at the beginning of the twenty-first century with the style trend called "Cool Japan" and the Tokyo street fashion fad of dressing as if one were a figure right out of a manga.[2] In light of these developments and the worldwide reappraisal of Japanese culture, the Kyoto Costume Institute began to reassess the image of Japan, particularly the glamorous perception of its fashions from the 1980s on. Designers such as Issey Miyake, Rei Kawakubo (b. 1942), and Yohji Yamamoto, who approached clothing from a perspective very different from that prevalent in the West, constructed creative and bold styles. For the first time, the West became aware of alternative views of the relationship between clothing and the body.

Future Beauty made it clear that fashion had embraced post-modernism and that Japanese styles freed fashion from the symbolic function of clothing that had been prevalent in the West. Between 2010 and 2015 the exhibition appeared at the Barbican Art Gallery, London; the Haus der Kunst, Munich; the Museum of Contemporary Art, Tokyo (fig. 2); the Seattle Art Museum; the Peabody Essex Museum, Salem, Massachusetts; the National Museum of Modern Art, Kyoto; and the Gallery of Modern Art, Brisbane, Australia. *Future Beauty* reaffirmed the distinctive characteristics of modern Japanese fashion. At the same time, it proved that the traditions of Japanese clothing culture that seemed to have temporarily died out—particularly the textile techniques and sensibilities that had fostered the kimono—continue to inspire modern Japanese designers.

Kimono Refashioned

Kimono Refashioned addresses a new topic: the influence of kimono on modern fashion. Japanese style is more evident than ever before in contemporary fashion movements. As in the past, elements of its clothing culture are again being reinterpreted; that is, such things as the incorporation of kimono textile designs, the adaptation of specific kimono forms, and flat construction are continually being given new interpretations.

Within this context, special mention should be made of the interest in traditional—and unique—Japanese weaving and dyeing techniques, which have been a source of inspiration not only to Japanese but also

Fig. 2
Installation view of *Future Beauty: 30 Years of Japanese Fashion* at the Museum of Contemporary Art, Tokyo, 2012.

to Western designers. The kimono and obi, with their essentially simple shapes, draw attention to the textiles from which they are made, so the Japanese have devised various sophisticated techniques to highlight subtle differences in fabrics. For instance, the brocaded fabrics, generally woven with gold threads, used to make women's obi stun us with their magnificence today just as they did in the past. Yohji Yamamoto used this kind of full-bodied brocaded fabric to create a modern dress with a three-dimensional form (cat. 29). Kimono are frequently made from magnificent fabrics that have a woven pattern and then are dyed with designs and finally enhanced with embroidery. These exquisite, pictorial designs inspired Western painters at the end of the nineteenth century, and many designers remain charmed by kimono fabrics today, as can be seen in the dress designed by John Galliano (b. 1960) for Christian Dior (cat. 36).

The sophisticated Japanese art of *shibori*—a term describing various types of bind-resist dyeing, including tie-dye, stitch-and-bind-resist, and clamp-resist dyeing—has likewise attracted great attention from prominent designers. Such techniques, practiced around the world since ancient times, are said to have come to Japan during the eighth century. In addition to the characteristic patterns it creates, vividly seen in the dress designed by Rei Kawakubo for Comme des Garçons (cat. 30), many contemporary designers have embraced the tactile qualities *shibori* produces in a piece of fabric—the protrusions decorating its surface and its inherent elasticity. Examples include Iris van Herpen (b. 1984), who played off the dimensionality of *shibori* (cat. 33), and Maurizio Galante (b. 1963), who cultivated a new genre of elastic *shibori* (cat. 31).

The various textile techniques of Japan are not limited to elite kimono; many types of fabrics have been employed in the production of everyday clothing. Modern fashion, which emphasizes the casual and the comfortable, has turned to these techniques enthusiastically. Typical fabrics familiar to the Japanese populace are cottons dyed with durable indigo using stencil-resist patterns. Rei Kawakubo used such patterns in her early work (cat. 41). Most recently, attention has focused on *boro*, everyday clothing worn by Japanese farmers until it was threadbare and given extended life by extensive patching (see cat. 43). Interest in *boro* is directly related to the reaction against the fast fashion trend of the twenty-first century, a heightened appreciation for handmade work, and a respect for sustainability—all of which can be seen in the outfit designed by Junya Watanabe (b. 1961; cat. 42). Indeed, it has become impossible for the fashion world to ignore the concept of sustainability.

Clothing for everyone drives fashion in the twenty-first century. Unlike the West, where palace culture took the lead, Japan has long embraced more humble sources of creativity. Beginning in the seventeenth century, the economic power of the merchant class rose and produced a vibrant urban culture. Its ukiyo-e prints and illustrated stories (*kibyōshi*) are early precursors to modern manga and anime.

Fig. 3
Tunic and jacket by Jonathan Anderson (Irish, b. 1984) for Loewe, Spring/Summer 2016, cat. 47.

Further, Edo-period (1615–1868) city dwellers were not constrained by the traditional designs of the kimono; instead, they instinctively followed their tastes, incorporating the "non-standard dress of women entertainers and Kabuki actors to bring in a wealth of designs that had been inconceivable up to that time."[3] Here we find a connection to the pop sensibilities of today's Tokyo street fashion. A key characteristic of this modern style is its playfulness, its freedom from the symbolism and protocol of clothing as stipulated by Western fashion. For example, in Tokyo a child's coat might be worn by an adult as a skirt, with the childish colors and designs freely rearranged into an adult garment. The sensibilities of modern Japanese pop are part of an unbroken legacy of Japanese folk culture (see fig. 3).

Conclusion

In *Kimono Refashioned* the Kyoto Costume Institute has condensed some thirty years of study on the influence of kimono on Western fashion. The institute's exhibitions may appear intermittently, but they persistently ask: "What is the kimono?" and "What is Japaneseness?" It is our duty as scholars of Western fashion in Japan to search for the Japaneseness in fashion as an expression of the hypervernacular, which we believe is closely connected to the institute's mission of articulating a vision for the fashion of tomorrow.

CATALOGUE

KIMONO IN PAINTINGS

Emerging from a long period of isolation in 1854, Japan attracted intense attention in the West. During this time, a series of international expositions were held in Europe and America, providing a stage on which a variety of Japanese articles could be exhibited. Once such products as woodblock prints (ukiyo-e), lacquerware, ceramics, and kimono began to be exported in large quantities, Japan's culture and lifestyle became much more accessible to people in the West. As Westerners became aware of Japan, hitherto only a vaguely perceived Asian country, the craze for Japanese art known as "Japonism" began to spread.

It was against this backdrop that European and American painters turned their attention to "Japan" as a new artistic theme. One element was traditional Japanese dress—the kimono—which appeared in numerous paintings as a clear symbol of the country. In works such as James McNeill Whistler's 1863–65 painting *The Princess from the Land of Porcelain* (p. 4; fig. 1) and Jacques-Joseph James Tissot's *The Japanese Bath* (1864), the kimono allows the wearer to dress up as a Japanese woman and entice the viewer into an unknown world; it also sometimes served as a drapery decorating a room in exotic style or as an elegant casual robe.

The dark gray cloth covering the exhibition stand in the lower left of Tissot's *Young Women Looking at Japanese Articles* (cat. 1) is a kimono. In William Merritt Chase's *Girl in a Japanese Costume* (cat. 2) we find kimono worn as a stylish dressing gown, as was the fashion of the day. This type of kimono, typical of those worn by warrior-class ladies from the mid-seventeenth to mid-eighteenth century, was known in Japan as *kosode*. They are decorated with conventional landscape patterns in *yūzen* dyeing and gold- and silk-thread embroidery on a silk crepe or figured satin ground—features that Tissot and Chase accurately rendered in their paintings. *Kosode* of the type depicted here are preserved in many American and European galleries and museums (see cat. 3).

Cat. 1

Young Women Looking at Japanese Articles, 1869

By Jacques-Joseph James Tissot
(French, 1836–1902)
Oil on canvas
H. 70.5 cm x W. 50.2 cm

*Cincinnati Art Museum, Gift of
Henry M. Goodyear, MD, 1984.217*
Shown at AAMSF, CAM, Newark

An early collector of Japanese art, Tissot enthusiastically included many authentic Japanese objects from his personal collection in his paintings. An early example is a series of three canvases from 1869 titled *Young Women Looking at Japanese Articles*, one of which is shown here. Each set in Tissot's Paris home, these pictures are remarkably detailed and serve as a vehicle for the painter to parade his extensive collection of Asian wares. In this version, two fashionably dressed young women survey an impressive model of a Japanese trading ship in a room filled with Asian objects: an ornate lacquered cabinet displaying kimono-clad dolls, Japanesque screens at the windows, a Persian rug, and a blue-and-white ceramic bowl. Not to be overlooked is the textile draped over the wooden box on which the ship rests. This gray "drapery" is, in fact, a kimono of the style worn by women of the samurai class from the mid-seventeenth to the mid-eighteenth century (see cat. 3). It would have been constructed of silk and, in the painting, is clearly hand embroidered and printed or stenciled with traditional floral motifs, bamboo, and swirling streams. Tissot painted it in great detail, including the commonly

used bright orange lining and a seam, often mistaken for a fold, running vertically up the side and onto the surface of the box. —CA

Cat. 2

Girl in a Japanese Costume,
approx. 1890

By William Merritt Chase (American,
1849–1916)
Oil on canvas
H. 62.5 cm x W. 39.8 cm

*Brooklyn Museum, Gift of Isabella S.
Kurtz in memory of Charles M. Kurtz,
86.197.2*
Shown at AAMSF, CAM, Newark

Japonism took many forms, including
the literal inclusion of kimono or
Japanese accessories and objects—
including *inro* boxes, swords, fans,
bronzes, lacquers, and ceramics—as
compositional elements in portraits
of Caucasian women. Here we see
that Chase dressed his model in a
decorative silk kimono, possibly one
made for export to Western collectors.
Like many of his patrons, Chase
was a collector of Japanese art and
design, and his studio would have had
many kimono and other Asian textiles
for use as garments and props.
Despite the availability of objects and
furniture that could have been used
as an exotic stage set, Chase chose
to portray his model in a naturalistic
manner before a plain background,
seated in a three-quarter pose,
depicted from the waist up, with her
hair and makeup treated no differently
than if she were wearing any other
fashionable garment. The kimono,
although identifiably Japanese in
origin, was easily incorporated into
late-nineteenth-century interiors and
artistic environments, reflecting the
cosmopolitan tastes of Americans
and indicative of the kimono's
cultural fluidity for more than a
century.—KGO

Cat. 3

Long-sleeved kimono (*furisode*), mid-1800s

Japan, Edo period (1615–1868)
Silk crepe with printing or stenciling, silk-floss embroidery, and gold-thread couching
Design featuring motifs of cherry trees, peonies, hills, waterfalls, bamboo, clouds, and lion-dogs (*komainu*)
Cincinnati Art Museum, Gift of Edward Senior, 1974.16
Shown at CAM

The origins of the kimono can be traced to China and the front-wrapping robe with rectangular sleeves of the Han dynasty (206 BCE–220 CE). Once adopted by the Japanese, the kimono took various shapes, but all styles retained a basic form—a geometric use of fabric, an overlapping front, and attached neckband sewn along the front opening edges—that was wrapped and tied on the body.

The Edo period in Japan was one of unprecedented stability, both politically and economically, spurring significant urban growth. This burgeoning wealth often exhibited itself in clothing, despite stringent sumptuary laws. The broad expanses of cloth inherent in kimono construction offered artisans a canvas on which to express themselves, providing their clients a means to display their social rank and artistic sensibilities.

Constructed of fine silk crepe, this example is hand stenciled or printed with an overall design of blossoming trees, peony flowers, hills, waterfalls, bamboo, and clouds. Perhaps the most auspicious elements of the

design are the lion-dogs, or *komainu*, embroidered on the front and back. Traditionally shown in pairs, these creatures are said to ward off evil. Interspersed among the areas of embroidery are examples of *suri-hitta*—a stenciled form of *shibori*

(tie-dye). Spurred by the growing demand for labor-intensive *shibori*-decorated kimono, dyers developed this more expedient stenciled technique, using a paste-resist-and-dye process. — CA

JAPONISM IN FASHION

It is not surprising, with the spread of Japonism, that Western women were attracted to the kimono. In the 1880s fashionable outerwear and dresses made from panels of kimono fabric appeared in Paris and London: kimono were taken apart so their opulent silk material could be reused and adorned with completely novel decorative motifs (see cat. 4). From the 1880s onward, kimono patterns were adopted by textile makers in Lyon, which supplied fabric to high-fashion designers in Paris (see cats. 9 and 10). In this way, Japanese-style textile designs spread across the fashion world.

Wealthy women in Europe and America also started using the kimono as a dressing gown, attracted not only to its exotic beauty but also to its soft, loose fit and openness. In the twentieth century, this led to the emergence of a new type of dressing gown also known as the "kimono." So, from around 1900, kimono referred to Japan's national dress as well as these popular dressing gowns made in the West and garments produced in Japan for export.

At the start of the twentieth century, books about Japan, popular theatrical works with Japanese themes, and exhibitions of woodblock prints (ukiyo-e) fed widespread interest in Japan. The victory of Japan in the Russo-Japanese War in 1905 further boosted this interest. Between about 1907 and 1913 images of the kimono, as seen on beautiful women in ukiyo-e prints, appeared frequently in the Paris fashion world. The trend, which French magazines dubbed *Japonisme dans la mode* (Japonism in fashion), saw dresses with pulled-back collars and trailing skirts like those of ukiyo-e models, cocoon-shaped coats resembling the traditional *uchikake*, the unbelted kimono worn over *kosode*, and wide-waisted sashes like obi become all the rage (see cats. 13 and 14). The shape of the Japanese kimono on the body was re-created in traditional Western dressmaking.

Fashion changed dramatically after World War I, as greater emphasis was given to the functionality of women's clothes. In the early 1920s Madeleine Vionnet (1876–1975) took the lead in creating a new style that broke with the previous era, cutting fabric in straight lines to create loose shapes and uncontoured surfaces inspired by the distinctive flat construction of the kimono (see cat. 17). The waist having been liberated from the corset, and the rectangular, tubular silhouette flooding the mainstream, the influence of kimono construction was evident in countless garments (see cat. 18).

From the late nineteenth century through the 1920s, in both the East and the West, the kimono and Western fashion became profoundly intermingled. In that era, the kimono provided fashion designers with a new source of inspiration whose influence touched textile design, form, and construction.

Cat. 4

Dress, 1876–78

Turner
Label: Misses Turner Court Dress
Makers, 151 Sloane Street, London
Bodice and overskirt: silk satin damask
(*rinzu*) with silk and metallic-thread
embroidery
Design featuring wisteria, chrysan-
themum, peony, and Chinese-fan
motifs
*Collection of The Kyoto Costume
Institute*, Inv. AC8938 93-28-1AB
Shown at AAMSF, CAM, and Newark

The dress by Misses Turner Court
Dress Makers was fashioned in
London from a dismantled *kosode*,
the Edo-period garment worn by
elite women of the Japanese military
aristocracy. The bodice and overskirt
are constructed from what had been
a single *kosode* (see fig. 1). Traces
of the *kosode*'s original stitches can
still be seen. The underskirt is made
from different material, as was the
habit at the time. Similar examples of
Western dresses made from *kosode*
can be found in the Musée de la
Mode de la Ville de Paris and in the
Chokokan Museum, Nabeshima,
among other museums.

In addition to retailoring them into
haute couture garments, European
and American women wore authentic
unaltered Japanese kimono as
indoor dressing gowns, prizing the
gorgeous fabrics that combine
multiple decorative techniques, such
as weaving, dyeing, and embroidery
(see cat. 5). Western artists were
quick to appreciate this trend,
making kimono-clad women (and
settings) a common theme in their
paintings (fig. 2). — NT

Cat. 5

Kimono, approx. 1800–1868

Japan, Edo period (1615–1868)
Silk satin damask (*rinzu*) with silk and metallic-thread embroidery
Design featuring wisteria, chrysanthemum, peony, oxcart-wheel, and maze-pattern motifs

Collection of The Kyoto Costume Institute, Inv. EQ257
Shown at AAMSF, CAM, and Newark

Fig. 1
Pattern for dress, approx. 1875, cut from a disassembled kimono.

Fig. 2
Madame Hériot, 1882. By Pierre-Auguste Renoir (French, 1841–1919). Oil on canvas; H. 65 cm x W. 54 cm. Hamburger Kunsthalle, Troplowitz Bequest, 1920, HK-2354.

Cat. 6

Ball gown, approx. 1888

House of Rouff
Label: Paris Rouff Paris
Two-piece dress; silk satin with
sequins and silver-thread embroidery
Brocaded train featuring plant
(possibly fern) patterns
*Collection of The Kyoto Costume
Institute*, Inv. AC7068 92-5-3AB
Shown at AAMSF, CAM, and Newark

The woven-leaf pattern on this brocaded silk resembles a fern. Awareness of ferns, which until then had not received much notice in the West, is related to the Japanese interest in plants. The back of the skirt still has the remnants of a bustle—until recently, a fashionable detail—while the train of the gown employs a showy, heavy brocaded silk made in Lyon. The fern motif here matches a Japanese textile in the Musée des Tissus et Musée des Arts Décoratifs, Lyon, which presumably served as its model.

In the mid- and late nineteenth century, the Lyon silk-weaving industry, an important producer of fabrics for Paris, turned to Japonism as a source of designs. Haute couture designers employed these textiles to create the newest fashions, which were then sent out into the world.

The House of Rouff, established in Paris in 1884, was situated on the Boulevard Haussmann. The designer Jeanne Paquin (1869–1936), who was influenced by Japanese art and kimono, is thought to have trained at this fashion house. — TS

Cat. 7

Coat (visite), approx. 1890

Possibly House of Worth
Cashmere twill with silk appliqué
and feathers
Design featuring samurai-helmet
(*kabuto*), folding-fan, and cherry-
blossom motifs on the front, collar,
back, and back slit
*Collection of The Kyoto Costume
Institute*, Inv. AC5367 86-17-7B
Shown at CAM and Newark

This garment boasts a design of
samurai helmets (*kabuto*), folding
fans made of cypress slats (*hiōgi*),
and cherry blossoms. Such motifs—
evidently inspired by Japanese
kimono, textiles, and other arts
and crafts—often appeared in
fashionable clothes featuring
Western materials and silhouettes,
indicating the popularity of Japanese
designs in this period. At the same
time, the layout of these Japonesque
elements is here given a European
spin, with the helmets set at an angle
and symmetrically aligned. These
various decorations were woven
into a separate piece of silk and
appliquéd onto the cashmere with
cord embroidery.

A visite was a type of coat ample
enough to cover a bustle-style dress.
A slit running from the waist to
the hem at the back allows for the
large backside characteristic of the
form.—MI

Cat. 8

Day dress, approx. 1897

By Jacques Doucet (French, 1853–
1929)
Doucet
Label: Doucet
Two-piece dress with belt; wool twill,
silk satin, and silk chiffon with appliqué
and enamel
Design featuring Japanese iris
(*kakitsubata*) motifs on the shoulders,
sleeves, and hem
*Collection of The Kyoto Costume
Institute*, Inv. AC10426 2001-1-2ACB
Shown at AAMSF, CAM, and Newark

Although irises had figured in the
imagery of European heraldry, they
became identified with Japanese
art at the end of the nineteenth
century after the introduction of
the artistic style of the painter and
designer Ogata Kōrin (1658–1716)
in magazines such as *Le Japon
artistique* (*Artistic Japan*) and
were frequently incorporated into
Western paintings, crafts, and
textiles. The motif of densely packed
irises—bringing to mind a field of
Iris laevigata (*kakitsubata*)—often
appeared on kimono, as evidenced

by ukiyo-e prints (see fig. 1) and
design books (see fig. 2) and was
a main theme in paintings such as
Irises at Yatsuhashi (after 1709) by
Kōrin. The asymmetrical arrangement
of irises on this day dress underlines
the influence of Japanese designs.

Doucet opened around 1817 as
a shop selling lace and lingerie and
expanded into high fashion around
1870. Jacques Doucet, a designer
who established the firm's reputation
in haute couture, was an astute art
collector who purchased numerous
East Asian artworks, including many

from Japan. He was totally taken
with the trend of Japonism and,
as can be seen in this innovative
work, incorporated it into his own
designs.—MI

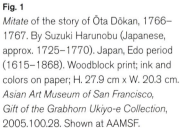

Fig. 1
Mitate of the story of Ōta Dōkan, 1766–
1767. By Suzuki Harunobu (Japanese,
approx. 1725–1770). Japan, Edo period
(1615–1868). Woodblock print; ink and
colors on paper; H. 27.9 cm x W. 20.3 cm.
*Asian Art Museum of San Francisco,
Gift of the Grabhorn Ukiyo-e Collection*,
2005.100.28. Shown at AAMSF.

Fig. 2
Kimono pattern with iris motif, 1674.

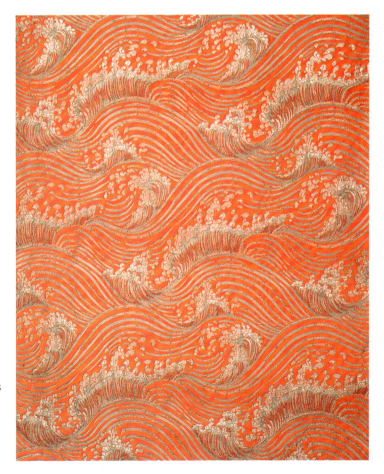

Cat. 9 (top)

Textile, approx. 1889

J. Béraud & Cie, Lyon, France
Silk satin with broché, lancé, and liseré patterning
Design featuring morning-glory and grass motifs
H. 153 cm x W. 66 cm (overall);
H. 49.5 cm x W. 61 cm (pattern repeat)
Collection of The Kyoto Costume Institute, Inv. AC7601 92-23-9
Shown at CAM and Newark

By the end of the nineteenth century, designers' interest in things Japanese extended to flora. Here, grasses and flowers previously absent from Western textiles are depicted in their freshly picked, natural form with impressive realism using extremely refined techniques. On an ivory silk-satin ground, morning glories and leaves are rendered in broché, while the grasses are depicted in lancé and liseré. In broché, colored wefts are woven only in the pattern area (discontinuous supplementary weft patterning), while lancé patterning has the colored wefts passing from selvage to selvage, appearing on the surface only where needed (continuous supplementary weft patterning). Liseré uses the same weft threads as the foundation of patterning (self-patterned).

This piece has the same design as a fabric entered in the 1889 Paris Exposition Universelle by the Lyon-based company J. Béraud & Cie as well as one in the Musée des Tissus et Musée des Arts Décoratifs, Lyon (Inv. 24889).—MS

Cat. 10 (bottom)

Textile, approx. 1912

France
Silk damask with broché patterning
Design featuring wave patterns
H. 173 cm x W. 95 cm (overall);
H. 34 cm x W. 23.5 cm (pattern repeat)
Collection of The Kyoto Costume Institute, Inv. AC937 93-27-3
Shown at CAM and Newark

In this silk damask, red warp and gray weft create a pattern of waves and eddies, with spray from the waves highlighted with silver discontinuous patterning threads (broché). The wave motif was considered typically Japanese and represented a new trend in textiles produced in France—one that became especially popular in the 1920s. Around this time publications—such as *Étoffes Japonaises tissées et brochées* (*Japanese Woven and Brocaded Fabrics*, 1910)—appeared featuring color reproductions of Japanese textiles from the seventeenth to the nineteenth century, including examples similar to this design.

In 1913 the J. Claude company (founded around 1839) assembled a book collecting samples of silk fabrics produced all over France between July 6, 1912, and August 7, 1913. A swatch of this pattern, dated August 6, 1912, is included in that book, now in the collection of the Kyoto Costume Institute.—MS

Cat. 11

Evening coat, approx. 1910

Possibly France

Gold damask lamé, silk velvet, and fur
with metallic lace and metallic and silk
cord

Design featuring floral motifs with
dolman sleeves and knotted tassels

*Cincinnati Art Museum, Gift of William
Mack*, 1943.25

Shown at CAM

By the late 1860s the influence of
Japanese aesthetics was apparent
in European and American art.
Parisians first saw Japanese arts
and crafts at the 1867 Exposition
Universelle. Liberty & Co., established
in 1875, imported silks from Asia
and in 1884 opened its costume
department. Artists such as Édouard
Manet (1832–1883) and Vincent
van Gogh (1853–1890) became
avid collectors of ukiyo-e prints.
French designer René Lalique
(1860–1945) incorporated Japanese
aesthetics into his jewelry. English
ceramics firms Royal Worcester
and Mintons adapted Imari-ware
styles, while Gorham introduced
Japanesque motifs into its silverware.
Manufacturing textiles since the
fifteenth century, the French silk-
weaving industry in Lyon was by the
late nineteenth century producing
textiles incorporating Japanese
motifs that were in turn utilized by
French couturiers.

In both its form and the textile
from which it is constructed, this
evening coat demonstrates the effect
of Japonism on fashion. With a loose
fit overall and a dolman sleeve that
is cut in one piece with the body of
a garment and has a low armhole,
the coat is equally, if not more
expansive, than the kimono shape
that inspired its design. The body is
cut from a complex damask lamé
fabric that was probably produced
in Lyon. The pattern combines a
Japanese chrysanthemum motif
with Western-style scrolling leaves
and berries and is overlaid with
impressionistic colors and shapes
resembling flowers. The neckline
closure and elaborate tassels are
reminiscent of traditional Japanese
decorative knot tying. —CA

Cat. 12

Evening dress, approx. 1913

Possibly House of Worth
Silk tulle and silk satin with bead
embroidery
Design featuring Japanese motifs
on both the train and the tunic-style
double-layered front bodice

*Collection of The Kyoto Costume
Institute*, Inv. AC7764 93-18-5
Shown at CAM

Creations inspired by the clothing
worn by women depicted in ukiyo-e
prints became more prominent in
French fashion around 1910—
a reflection of the increasing
opportunities for Western artists
and designers to see Japanese
designs through publications by the
likes of British designer Christopher
Dresser (1834–1904) and architect
T. W. Cutler (1842–1909). This
gorgeous tunic-style evening dress,
with tulle covering a cream-colored
silk satin and white-and-silver bead
embroidery, is a prime example.
The silhouette of the dress recalls
the kimono of an ukiyo-e beauty
with flared, trailing hem (*ohikizuri*;
see fig. 1). It is entirely covered
with motifs that might be thought
of as Japanese: plum blossoms
adorn the elegant train, and flowers
and mist (*kasumi*) patterns, along
with linked circles and squares
called *kakuwachigai*, are placed
dynamically over the entire garment
and are reminiscent of designs
popular in Japan during the mid-Edo
period. — MM

Fig. 1
A courtesan wearing a robe decorated
with actors' crests, approx. 1715.
Attributed to Torii Kiyonobu I (Japanese,
1664–1729). Japan, Edo period
(1615–1868). Woodblock print; ink on
paper; H. 57.8 cm x W. 31.7 cm. *Asian
Art Museum of San Francisco, Gift of the
Grabhorn Ukiyo-e Collection*, 2005.100.2.

Cat. 13

Evening dress, approx. 1910

By Lucy Duff-Gordon (British, 1863–1935)

Lucile Ltd.

Label: Lucile Ltd., 17 West 36th Street, New York

Dress: silk cut velvet, silk twill, and silk organdy; sash: silk twill; corsage: lamé Design in a wave-patterned fabric featuring kimono sleeves, obi-like sash, and train

Collection of The Kyoto Costume Institute, Inv. AC13153 2014-29AB Shown at AAMSF, CAM, and Newark

This evening dress from Lucile Ltd. was inspired by kimono, having a kimono-style sleeve without a shaped armhole and an obi-like sash. This dress is a typical example of what French fashion magazines of the day called *Forme Japonaise* in reference to the shapes of kimono worn by beauties depicted in ukiyo-e prints (see fig. 1).

Margaret Augusta Daly Brown (1873–1911)—the daughter of the American millionaire Marcus Daly (1841–1900), known as one of the "Copper Mine Kings"—wore this dress. She married the Baltimore banker Henry Caroll

Brown (1874–1958) and commuted back and forth between the society scenes in that city and New York.

This dress is said to be part of the collection that marked the 1910 opening of the New York branch of the Lucile Ltd. couture house. The original atelier, Maison Lucile, was opened in London in 1893 by the British designer Lady Duff-Gordon, born Lucy Christiana Sutherland. In the 1910s, with an eye on the giant American market, Lucile Ltd. branches opened in New York and Chicago and were highly popular among wealthy women. — RN

Fig. 1

Washday, 1788. By Torii Kiyonaga (Japanese, 1752–1815). Japan, Edo period (1615–1868). Woodblock print; ink and colors on paper; H. 38 cm x W. 25.4 cm (each). *Asian Art Museum of San Francisco, Gift of the Grabhorn Ukiyo-e Collection*, 2005.100.68.a-.c. Shown at AAMSF.

Cat. 14

Evening coat, approx. 1913

House of Amy Linker
Label: Amy Linker, Linker & Co.
Sps., 7 Rue Auber, Paris 010070
(handwritten)
Silk satin and silk crepe with bead
embroidery
Design featuring a pulled-back striped
collar and loose drapes, embellished
with floral and Asian motifs
*Collection of The Kyoto Costume
Institute*, Inv. AC3775 81-8-1
Shown at AAMSF, CAM, and Newark

This silhouette coat is a good example of eclectic Orientalism at the beginning of the 1910s. Called a *manteau Japonaise* (Japanese coat) in French fashion magazines of the early twentieth century, it evokes the *uchikake* worn over kimono as depicted in ukiyo-e prints (see fig. 1), just as the bold stripes on the collar recall the extra (*date-eri*) collar of Kabuki costumes. The flower design rendered with bead embroidery is called *hanakatsumi*, a traditional Japanese motif that, thanks to its popularity among Kabuki actors, became fashionable at the end of the Edo period. The border decoration at the back, however, resembles ancient Mediterranean designs, so the *hanakatsumi* may actually be a palmette, which can be traced back to Greek and Roman art.

The Paris couture house Amy Linker opened in 1900 and, known for its coats and suits, received ample coverage in early-twentieth-century fashion magazines. —RN

Fig. 1
Cover of a special edition of *Paris Illustré (Paris Illustrated)* from May 1886 featuring a reproduction of a woodblock print of a courtesan by Keisai Eisen (1790–1848).

LE CHOIX DIFFICILE
Manteau du soir de Worth

Fig. 2
Illustration of an evening coat by the House of Worth published in *Gazette du Bon Ton*, 1914.

Cat. 15

Dress, 1920–1930

By Paul Poiret (French, 1879–1944)
The House of Paul Poiret
Dress and belt: silk crepe, tie-dyed, with stenciling
Design inspired by *haori*, with traditional Japanese motifs
Collection of The Kyoto Costume Institute, Inv. AC11551 2006-17-1AB
Shown at AAMSF, CAM, and Newark

A leader in adopting new trends, Poiret, who opened his store in 1903, had keen insight into the fashion sensibilities of the early twentieth century. He presented a dress without a corset in 1906 and later introduced a series of works influenced by the avant-garde Ballets Russes that incorporated motifs from Egypt and Eastern Europe, among other sources. As he sought to break away from nineteenth-century-style clothing that conformed to and restricted the body, he worked to create a straight cut and gentle drape in his dresses, drawing on clothing features from several countries, including Japan.

Poiret's wife, Denise, is said to have worn this dress, tailored to suggest a black woven *haori*, or short coat, worn over a gray kimono. The *haori*-style collar would have allowed the wearer to wrap a stole around her neck. Judging from the linked weights motif (*fundō tsunagi*) in the background, the stenciled *shibori* pattern of linked semicircles, the area-dyeing (*okezome*) in gray and black, and the red seals stamped on the lining, the fabric might be of Japanese origin—a likelihood given that Poiret collected fabrics from around the world.—MO

Cat. 16

Evening coat, approx. 1927
By Gabrielle "Coco" Chanel (French,
1883–1971)
Chanel
Label: Chanel
Silk crepe with gold brocade
Design featuring a chrysanthemum
motif and padded cuffs
*Collection of The Kyoto Costume
Institute*, Inv. AC9182 94-45
Shown at AAMSF, CAM, and Newark

Here, delicate gold chrysanthemum
designs have been woven into a
roughly textured silk crepe dyed so
the black shades into green. Known
as *nashiji-ori* ("pear-skin" weave),
textiles such as this—which recall
the *nashiji* (sprinkled gold) lacquer
technique—were part of the Art Deco
style prevalent at the time and exhibit
a fresh modernism. The cuffs of this
coat are filled with cotton padding—a
detail (according to the Metropolitan
Museum of Art, which has a similar
coat) inspired by the padded kimono
hems known as *fuki*.

Chanel opened a boutique in
Paris in 1910 and showed her
first complete couture collection in
1916. Her work changed radically in
the 1920s, embodying the style of
independent women living in modern
society, thus establishing the concept
of a new elegance grounded in
functional beauty. —RN

Cat. 17

Wedding dress, 1922

By Madeleine Vionnet (French, 1876–1975)

Vionnet

Label: Madeleine Vionnet, No. 14053 (stamp), 4490 (handwritten), fingerprint stamp

Silk faille with silk tulle embellishments

Straight-cut design with a puffed bow at the back and rose embellishments by Lesage on the train

Collection of The Kyoto Costume Institute, Inv. AC7007 91-15-3A

Shown at AAMSF, CAM, and Newark

This wedding dress clearly indicates Vionnet's interest in Japan and its clothing. The pattern is constructed of rectangular panels, just like a kimono (fig. 1), and it is characterized by a tubular silhouette that emphasizes neither a narrow waist nor the swelling of the breast and hips—a stark departure from earlier fashions. A bow fluffs up at the back, creating the effect of an obi.

Vionnet first became interested in Japonism while working for Callot Sœurs, and she collected kimono and ukiyo-e. She opened her own fashion house in 1918 and through the first half of the 1920s made dresses with kimono sleeves and many loose-fitting pieces that draped evenly over the body. These designs illustrate Vionnet's search for a new relationship between garment and wearer, one that departed from traditional Western garment construction based on tailoring clothing to fit the contours of the body.—KT

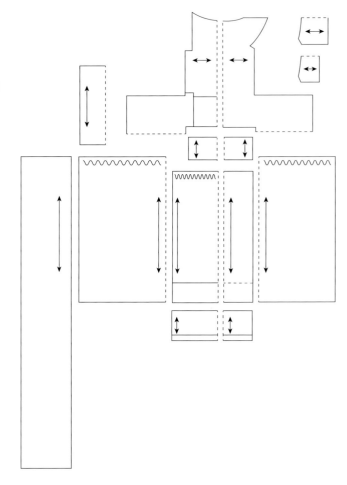

Fig. 1
Pattern for wedding dress, 1922.

Cat. 18

Evening dress "Henriette"

By Madeleine Vionnet (French, 1876–1975)

Vionnet, Winter 1923

Label: Madeleine Vionnet, No. 26288 (stamp), fingerprint stamp

Gold and silver lamé plain weave, pieced

Design featuring a geometric patchwork pattern

Collection of The Kyoto Costume Institute, Inv. AC6819 90-25A, Gift of Mr. Martin Kamer

Shown at AAMSF, CAM, and Newark

The straight planes are remarkable in this tubular dress, which has neither darts nor structural grafting lines, only side tucks. A deliberate looseness is maintained between the body and the dress, unconstrained by tight binding. This lends the garment a free and highly expressive shape that emerges from the movements of the wearer. This pattern is called "Interlaced Ts" and features fifty-six pieces of gold and silver fabric cut into T shapes and sewn together. This traditional motif (*choji-tsunagi*) and the dress's straight and flat silhouette indicate a strong Japanese influence. Light bounces off the fabric in unexpected ways, bringing to mind the quality of Japanese *maki-e* lacquerware sprinkled with gold or silver powder and the illumination of a folding screen in flickering candlelight.

In her constant search for new design potentialities, Vionnet was captivated by Japanese concepts and aesthetics, which provided her with invaluable insights. Many of her pieces demonstrating this influence were made in the first half of the 1920s. — KT

Fig. 1
Design registration photo for evening dress "Henriette," deposit no. 7194 of January 24, 1924, serial no. 52, model no. 2074. Archives Musée des Arts décoratifs—UFAC collection, Paris.

Fig. 2
Pattern for evening dress "Henriette."

As the kimono captured imaginations in Europe and America in the second half of the nineteenth century, the Japanese were beginning to embrace Western dress. After World War II, the kimono—which had been everyday dress for all Japanese people—was reserved for special occasions. Kimono culture was deeply rooted, however, and remained very much alive: when Hanae Mori (b. 1926) launched her collection in New York in 1965, she received acclaim for skillfully blending high-quality Japanese silks and elegant traditional patterns with Western styles. Her garments captured the sophisticated, exotic flavor of the Japanese kimono (see cat. 34).

Because the shape of the kimono is simple, variations on the form were traditionally expressed through the fabric itself—from refined, elegant materials to rustic folk cloths such as cotton or hemp. As dress became increasingly casual during and after the 1970s, Japanese designers such as Issey Miyake (b. 1938) found inspiration in ordinary, country kimono, highlighting distinctive local fabrics from various regions of Japan. And now that sustainability has become a watchword in the fashion world, appreciation has grown for worn-out, used kimono and even for *boro*—ragged, darned, or patched kimono and fabric—from all around the country (see cats. 42 and 43).

The loose construction of the kimono—the total antithesis of Western tailoring—aroused a yearning for free and uncontrived new clothing styles. In 1977 Miyake launched *A Piece of Cloth*, a monumental exhibit in Tokyo that explicated his core design concept of creating clothing from single pieces of cloth that envelop the body; in applying this approach, called "A-POC," Miyake has reconfigured geometrically cut kimono-like fabrics into modern clothing (cats. 19–23). In the early 1980s designers such as Rei Kawakubo (b. 1942) and Yohji Yamamoto (b. 1943) also attracted attention for opening up new horizons in clothing design with their linear clothing featuring shapes unrelated to the human form.

Even in the twenty-first century, the fabric designs, stylishness, and composition of the kimono continue to provide a wealth of ideas to the fashion world. Designers find inspiration in the unparalleled richness of traditional Japanese dyeing and weaving techniques—be it opulent gold brocade, intricate *yūzen* dyeing, *shibori* tie-dyeing, or simple, homely fabrics—as well as by the elegant bearing and distinctive form of the kimono-clad figure. There is no doubt that the kimono remains an inexhaustible wellspring of ideas.

Cat. 19

Rhythm Pleats Dress

By Issey Miyake (Japanese, b. 1938)
ISSEY MIYAKE, Spring 1990
Label: ISSEY MIYAKE
Polyester and linen, pleated
Design featuring a flat circular shape,
three-quarter-length sleeves, and a
horizontal neck opening

*Cincinnati Art Museum, Museum
Purchase with funds provided by
Friends of Fashion, 2007.109*
Shown at CAM

Since founding Miyake Design
Studio in 1970, Issey Miyake has
explored ideas about expansion
on many levels. From his earliest
collections, he was interested in
creating clothing from a single piece
of cloth—a concept he calls "A-POC"
(A Piece of Cloth, *Ichimai no nuno*
in Japanese), which has manifested
itself in various forms throughout
his career.

Although he prefers not to be
categorized as a Japanese designer,
Miyake creates fabrics and garments
that frequently allude to the culture,
textiles, and dress of Japan, often
in veiled fashion. His focus on the
Japanese notion of *ma*—the space
between the body and the cloth—
explicitly references the kimono. The
expansive geometric cut of traditional
Japanese dress creates that space,
in contrast to Western fashion that
is customarily constructed to fit the
body closely.

In 1989 Miyake Design Studio
presented its first iteration of pleated
garments, and in 1990 the Rhythm
Pleats series—of which this dress is
an example—appeared in *Energieen*,
an exhibition at the Stedelijk
Museum Amsterdam. These designs
were exhibited both flat *and* on
the human body, emphasizing their
two-dimensionality *and* sculptural
presence. Taking the form of a circle
when laying perfectly flat, this dress
is constructed with an opening at the
bottom, a horizontal slit for the head,
and three-quarter-length sleeves.
Once on the body, it expands into
a garment that billows around
the figure; its roomy, comfortable
fit is a characteristic of Miyake's
clothing.—CA

Cat. 20

Dress

By Issey Miyake (Japanese, b. 1938)
and Reality Lab
132 5. ISSEY MIYAKE, Spring/
Summer 2011
Label: 132 5. ISSEY MIYAKE
Recycled polyester plain weave with
printing
Design featuring black fold lines

*Collection of The Kyoto Costume
Institute*, Inv. AC12462 2010-28-3
Shown at AAMSF, CAM, and Newark

Cat. 21

Dress

By Issey Miyake (Japanese, b. 1938)
and Reality Lab
132 5. ISSEY MIYAKE, Spring/
Summer 2011
Label: 132 5. ISSEY MIYAKE
Recycled polyester plain weave with
printing
Design featuring black fold lines

*Collection of The Kyoto Costume
Institute*, Inv. AC12463 2010-28-4
Shown at AAMSF, CAM, and Newark

Here, a folded piece of cloth is transformed, like origami, into a three-dimensional dress when lifted from the center. Refolded, it again becomes a flat square. Miyake describes the 132 5. line, which started in 2010, as follows: "The number '1' refers to the fact that one piece of cloth can become three-dimensional ('3'), and be refolded into its two-dimensional ('2') state again. The number '5' after the space signifies the temporal dimension that comes into being after the clothing is worn by people."[1] Using origami-design software developed by Jun Mitani (b. 1975), professor of computer science at the University of Tsukuba, Miyake's Reality Lab created designs featuring thin accordion folds of fabric, giving concrete shape to clothing. Like a piece of paper origami, the thin rectangle of fabric, folded along the scored lines after it is removed from the body, embodies a Japanese sensibility that has been fused with modern materials and techniques to create a new form in Miyake's creations.

Reality Lab, the in-company research team that Miyake and his staff formed in 2007, presents futuristic clothing designs like 132 5.—KT

Cat. 22

Dress

By Yoshiyuki Miyamae (Japanese,
b. 1976)
ISSEY MIYAKE, Autumn/Winter 2014
Label: ISSEY MIYAKE
Polyester/triacetate/polyurethane-
blend jacquard, pleated
Design using the 3D Steam Stretch
technique

*Collection of The Kyoto Costume
Institute*, Inv. AC13137 2014-21-5B
Shown at AAMSF, CAM, and Newark

Cat. 23

Dress

By Yoshiyuki Miyamae (Japanese,
b. 1976)
ISSEY MIYAKE, Autumn/Winter 2014
Label: ISSEY MIYAKE
Polyester/triacetate/polyurethane-
blend jacquard, pleated
Design using the 3D Steam Stretch
technique

*Collection of The Kyoto Costume
Institute*, Inv. AC13135 2014-21-3A
Shown at AAMSF, CAM, and Newark

These dresses follow organic lines inspired by those found in the natural world. The soft form, which bounces gently with the movement of the wearer, emerged from the new 3D Steam Stretch technique. Instead of standard cutting and darts, heat and steam are applied to folds woven into the material, with the result that the cloth naturally takes the shape of a dress. Free-flowing three-dimensional curved lines, impossible to create with standard pleats, give the dress a dynamic image. This design clearly embodies Issey Miyake's core concept of "A-POC"—A Piece of Cloth—where garments that begin as single flat pieces of fabric are completed and given form when placed on the human body (see cats. 19–21).

Miyamae started designing for ISSEY MIYAKE with the 2012 spring/summer collection. His elegant and sinuous modern designs fulfill the task given him by Miyake of extending established tradition by combining it with cutting-edge techniques.—KT

Cat. 24

Dress

By Rei Kawakubo (Japanese, b. 1942)
Comme des Garçons, Spring/Summer
2014
Label: Comme des Garçons
Cotton plain weave
Flat design overlaid with an abstract
motif
*Collection of The Kyoto Costume
Institute*, Inv. AC13089 2014-6-4A
Shown at Newark

Strong calligraphic lines wrap around
the two flat body panels that form
the front and back of this dress, as if
it were a page of writing. It brings to
mind the kimono, also constructed
of flat panels that function as a
canvas for dynamic compositions
rendered as if they were paintings or
calligraphy.

Kawakubo established her brand
in 1969 and presented her first
collection in Paris in 1981. She
showed plain, oversize, asymmetrical,
and monochromatic pieces that
departed from the prevalent Western
aesthetic of sumptuous, colorful,
body-conscious garments. Her
method of making clothes that are
not molded to the contours of the
body displays an understanding of
garment construction far removed
from Western norms. Rather, her
notions of design relate to the
similarly abstract form of the kimono.
Wrapped around the wearer, this
dress acquires a new form and
proclaims a universal beauty that
transcends the bonds of social
function or differences in individual
body shapes. — KT

Cat. 25

"Kabuki" dress

By Rudi Gernreich (American,
b. Austria, 1922–1985)
Harmon Knitwear, Autumn 1963
Label: Rudi Gernreich Design for
Harmon Knitwear
Wool jacquard knit
Check-patterned fabric with a V-neck
and obi-like trimming
*Collection of The Kyoto Costume
Institute*, Inv. AC9186 95-3
Shown at AAMSF, CAM, and Newark

This dress openly declares its inspiration in kimono. The black and white squares, the cylindrical silhouette, the deep-cut V-shaped neckline, the eye-catching pink waistband with its horizontal decoration reminiscent of a decorative cord (*obijime*)—all are made in the image of a kimono. The dress, however, remains a mere imitation, since it is fashioned from a jacquard knit and not woven fabric, and the waistband is not a belt but simply a decorative element. The kimono-like lines and the Japanesque geometric design resonate with Op art, making full use of illusion and optical theory, and are thus closely tied to elements of 1960s fashion.

Gernreich expanded the range of apparel design in 1960s America, devising, for example, unisex fashions. His focus on body movement led him to eagerly incorporate materials with elasticity like knits and spandex into his work. He had great respect for Japanese popular culture and produced works with such titles as "Sumo," "Kimono," "Japanese schoolgirl/schoolboy," and, here, "Kabuki."—MI

Cat. 26

Ensemble

By John Galliano (British, b. 1960)
John Galliano, Autumn/Winter 1994
Label: John Galliano Paris
Jacket: wool plain weave; belt: acetate
satin and silk lace
Double-breasted jacket with a train
and obi-like belt
*Collection of The Kyoto Costume
Institute*, Inv. AC9119 94-12-5,
AC9120 94-12-6
Shown at CAM and Newark

The base of this revealing micro-mini
ensemble is an orthodox black wool
double-breasted jacket but, with
its bold kimono-style collar, wide
sleeves, belt, and trailing train, it has
taken on the outward characteristics
of a kimono. Such works draw
on Galliano's assiduous study of
traditional Western tailoring methods
but result in an innovative style
inspired by garments old and new,
from East and West. The train trails
behind the wearer as she walks, and
the undergarment peeps out from
the side vents of the jacket—effects
that are surely the result of Galliano's
characteristic minute calculations.
After graduating from university
in 1984, Galliano went to work in
London and Paris, taking positions
at Givenchy and then Dior. In 2007,
to mark the sixtieth anniversary of
the house and his tenth year as
Dior's designer, he took "Japan" as
his theme for Dior's spring-summer
haute couture collection. —MM

Cat. 27

Jacket

By Tom Ford (American, b. 1961)
Gucci, Spring/Summer 2003
Label: Gucci
Rayon tricot with printing; silk tricot lining
Design featuring chrysanthemum and Japanese family-crest motifs, long kimono sleeves, and an attached collar

Collection of The Kyoto Costume Institute, Inv. AC10904 2003-10
Shown at AAMSF and Newark

This jacket, with its long sleeves and white collar band (*han-eri*), resembles a Japanese *juban* underrobe, and its cut and form and the placement of design elements further emphasize the influence of kimono. The upper section features a chrysanthemum pattern, while the lower part is printed with a design imitating a family crest representing the cross-section of a gourd known as *shihō mokkō* in Japanese. Traditionally, such crests are only used in formal decorations, but here they are employed in a manner unfettered by convention.

From 1994 to 2004 Ford was creative director at Gucci, reestablishing the Italian high-class leather brand as a luxury trendsetter. Ford specializes in minimal, sensual designs and has found a strong affinity with Japanese motifs. —MI

Cat. 28

Dress, 1956

By Toshiko Yamawaki (Japanese, 1887–1960)
Silk taffeta with Japanese gold-thread embroidery
Design featuring a wave motif

Collection of The Kyoto Costume Institute, Inv. AC12555 2011-8-35AB, gift from Yamawaki Fashion Art College
Shown at AAMSF, CAM, and Newark

Wild waves break across this dress of embroidered silk taffeta. The wave motif—which perhaps reached its zenith in the famous print *The Great Wave* by Katsushika Hokusai (1760–1849)—has been favored by the Japanese since ancient times and is used to ornament kimono and other items. The use of gold embroidery here further heightens the graphic impact of the wave.

Yamawaki was active as a designer before and after World War II. She extended the Westernization of clothing in Japanese society by opening a school that taught Western sewing techniques and publishing a book on the subject. Her own works often blurred the distinction between Western and Japanese clothing, blending the two traditions in innovative ways. This piece was among those displayed in the exhibition *Japanese Costume and Dressed Dolls: Kimonos d'hier et d'aujourd'hui* (Kimono of yesterday and today) at the Musée Cernuschi–Musée des Arts de l'Asie de la Ville de Paris in 1957. —MO

Cat. 29

Dress

By Yohji Yamamoto (Japanese, b. 1943)

Yohji Yamamoto, Spring/Summer 1995

Label: Yohji Yamamoto

Silk/rayon-blend jersey and polyester/rayon/nylon-blend brocade

Design featuring a chrysanthemum motif

Collection of The Kyoto Costume Institute, Inv. AC9166 94-34

Shown at AAMSF, CAM, and Newark

This dress is made from a showy red and gold brocaded fabric such as would be used for a luxurious obi waist sash. The garment has a unique construction: composed of a single rectangular piece of brocade and three pieces of jersey, it is essentially flat when placed on a flat surface, but when worn the jersey bow—crossed around the body and tied at the back—causes the brocade to stick out at the sides. The combination of gorgeous brocade and homely jersey gives this garment a modern nuance, and it stands as a fine example of the neo-Japonism of the mid-1990s.

Active since 1971, Yamamoto presented his first collection in Paris in 1981. With Rei Kawakubo, he sparked the so-called Japan Shock trend in Europe and the United States. While Japanese designers specializing in flat garments were sometimes criticized for producing formless clothing, Yamamoto, who is well versed in orthodox Western tailoring, is recognized as the Japanese designer closest to the West. At the start of his career Yamamoto did not directly incorporate any traditional Japanese aesthetic into his clothing, but he has since begun to introduce reconstructed elements of traditional kimono and obi into modern fashion. — TS

Cat. 30

Dress

By Rei Kawakubo (Japanese, b. 1942)
Comme des Garçons, Spring/Summer
1983
Label: Comme des Garçons
Cotton plain weave, bind-resist dyed
(*Miura shibori*)
Kimono-sleeve design with a single-
wrap dot pattern

*Collection of The Kyoto Costume
Institute*, Inv. AC7812 93-24-20, gift of
Comme des Garçons Co., Ltd.
Shown at Newark

When making a garment, Kawakubo
puts 80 percent of her effort into
creating the fabric. For this piece
she chose a typical *shibori* dyeing
technique from the Arimatsu-Narumi
area of Japan. In *Miura shibori*
(looped binding) a thread is wrapped
just once around each small section
of fabric without knotting it. This
allows the dye to seep into the
bound area. The result is a fabric
with blurred light blue, rather than
pure white, dots. This dress, with its
geometric designs of squares and
triangles, is a vivid illustration of the
range of expressive effects possible
with *shibori*.

After working in Tokyo for a
number of years, Kawakubo took
a leap forward in 1981 when
she began to present her work
in Paris. Her creations, which
stood outside Western garment
traditions, were both criticized and
applauded. This piece dates from
that period, when her work attracted
particularly intense attention for its
use of traditional Japanese dyeing
techniques. — MS

Cat. 31

Pullover

By Maurizio Galante (Italian, b. 1963)
Maurizio Galante, Haute Couture
Collection, Autumn/Winter 1994
Label: Maurizio Galante
Silk, tie-dyed (*te-kumo shibori*)
Design featuring a spiderweb binding
pattern
*Collection of The Kyoto Costume
Institute*, Inv. AC9155 94-28AB, gift of
Mr. Maurizio Galante
Shown at AAMSF, CAM, and Newark

Taking advantage of the texture
and elasticity possible in *shibori*, this
basic pullover combines modern
charm with traditional Japanese
dyeing techniques. For this piece
Galante chose to use the *te-kumo
shibori* method from the Arimatsu-
Narumi area. *Te-kumo shibori* is
among the oldest of the many
Arimatsu dyeing techniques and
gets its name from the pattern
it produces, which resembles a
spider's web, and is achieved by first
pleating and then binding the fabric.
In most *shibori* fabrics, the binding
threads are undone, the piece is
steamed, and the bound protrusions
are stretched flat; but for this piece
Galante skipped the flattening
process. The resulting fabric retains
the projections created by the
bindings, creating a unique design
and producing a stretchy material
that clings to the body perfectly. The
appearance of this pullover changes
depending on the body it covers, thus
bringing out new possibilities in a
traditional Japanese material. Traces
of the handiwork associated with
Arimatsu *shibori* can be seen here in
the remnants of binding threads in
the fabric.

After graduating from the
Accademia di Costume e Moda
in Rome, Galante set up his own
fashion house in 1985, winning
many prizes. Since 1993 he has
participated in the Paris haute
couture fashion week, showing
garments crafted from traditional
Japanese materials such as *shibori*
and *Nishijin-ori* brocaded silk. —MS

Cat. 32

Jacket, trousers, and sneakers

By Yusuke Takahashi (Japanese,
b. 1985)
ISSEY MIYAKE MEN, Spring/Summer
2014
Label: ISSEY MIYAKE MEN, ISSEY
MIYAKE INC.
Jacket: wool plain weave and
polyester/polyurethane-blend knit;
trousers: wool plain weave; sneakers:
suede; jacket and trousers clamp-
resist dyed (*itajime shibori*) with hand
printing
Design featuring gray wool dyed black
with a blue and red geometric pattern
*Collection of The Kyoto Costume
Institute*, AC13266 15-32AD
Shown at AAMSF, CAM, and Newark

The rhythmical, graphic design for
this standing-collar suit is made
with the traditional board-clamp-
resist (*itajime shibori*) technique, in
which fabric is folded and clamped
between wood blocks to prevent
certain areas from taking the dye.
This suit has a gray wool ground
fabric that has been dyed with an
intensely black latticework pattern,
created by the *shibori* technique, and
then hand printed with blue and red
blocks whose edges blur and bleed
to a thin *sumi* ink color. In an age of
digital printing and industrial textile
manufacturing, the chance effects
born of handcrafting heighten the
beauty of this ensemble. The ribbed
jersey material of the side panels
gives the jacket a casual, sporty feel.

Takahashi was in charge of ISSEY
MIYAKE MEN beginning with the
2014 spring and summer collection.
Feeling he ought to develop the
originality fostered by Miyake, an
enthusiastic proponent of inventing
new materials, Takahashi used
traditional Japanese techniques
to present this piece, which has
no associations with a specific
culture. — MS

Cat. 33

Dress

By Iris van Herpen (Dutch, b. 1984)
Iris van Herpen, Haute Couture
Collection, Autumn/Winter 2016
Label: Iris van Herpen
Polyester monofilament organza,
shibori tied, and cotton/elastane-
blend twill
Design featuring Super Organza
(*Ten'nyo no hagoromo*) fabric with
tie-dye (*shibori*) technique

*Collection of The Kyoto Costume
Institute*, Inv. AC13436 2016-17

Shown at AAMSF, CAM, and Newark

This minidress uses the thinnest,
lightest, half-transparent organza
in the world, woven from single
threads of polyester measuring five
to seven denier—about one-fifth the
diameter of a human hair. This is
Super Organza, also called *Ten'nyo
no hagoromo* (Heavenly maiden's
feather robe), woven in Nanao,
Japan. The fabric was inspired by
the realization that clothing could
be made from the single-thread
polyester originally developed
to shield components in plasma
televisions from electromagnetic
waves. Amaike Textile Industry
Co. Ltd. applied the *shibori* tying
technique to the Super Organza,
and Van Herpen used this unusual
material for her dress. Taking the
Super Organza, with its extremely
fine, bubble-like *shibori* depressions
facing outward, she stitched it in
layers to a black ground fabric; on
the sleeves and the front and back of
the skirt, she turned the fabric over
so the *shibori* protrusions formed a
curved silhouette.

Van Herpen established her
brand in 2007 and since 2011 has
presented works—like this one—
that combine handcrafting with
cutting-edge technology (such as
3-D printing) in Paris haute couture
collections. —MS

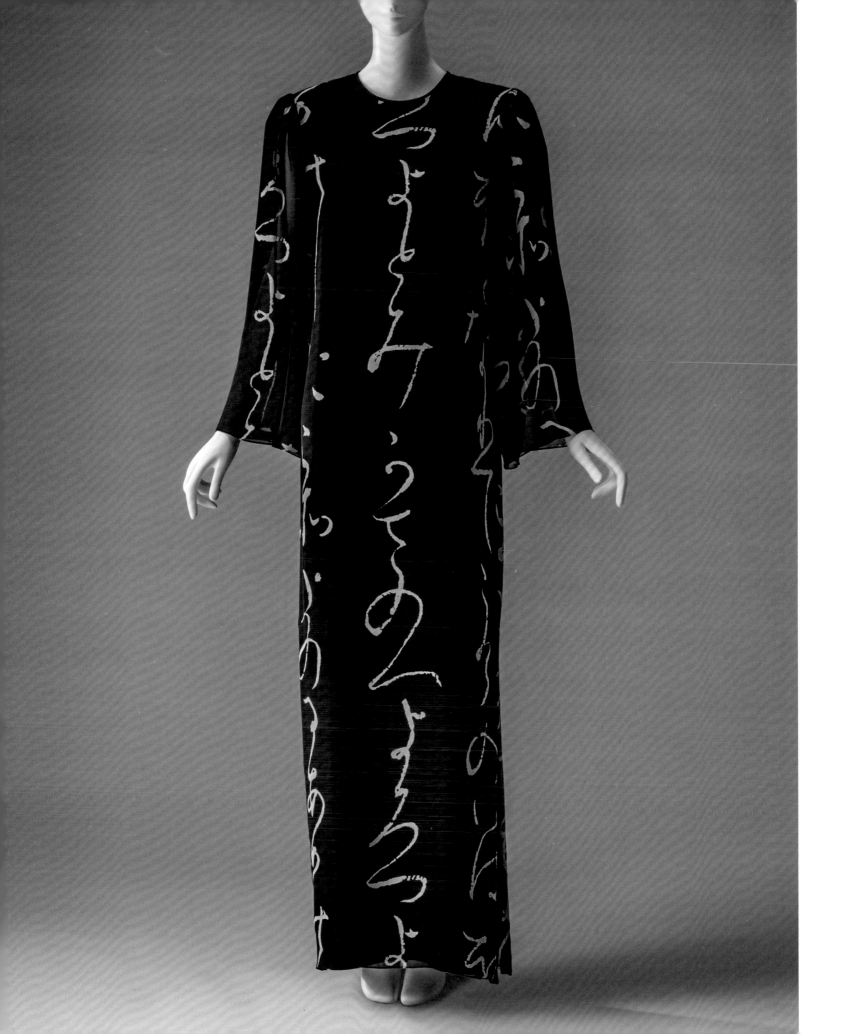

Cat. 34

Dress

By Hanae Mori (Japanese, b. 1926)
Hanae Mori, Autumn/Winter 1989
Label: Hanae Mori Boutique
Silk chiffon with printing
Design featuring a Japanese
calligraphy motif

*Collection of The Kyoto Costume
Institute*, Inv. AC13457 2016-28
Shown at AAMSF, CAM, and Newark

Lines—apparently from a Japanese poem—are written on the thin silk chiffon of this dress in the unique flowing Japanese script called *hiragana*. The brushstrokes appear in white on a black ground, so they seem to stand out in relief. The vertical rows of hand-calligraphed characters on the delicate fabric, the straight lines of the dress, and the puffy sleeves all sway back and forth with the movement of the wearer.

The practice of incorporating Chinese characters or Japanese script into garments began in the Heian period (794–1185) and became especially popular after the seventeenth century (see fig. 1). Later, script often appeared on clothing as an expression of Japanese chic, stylish and sophisticated, known as *iki*. In kimono, often decorated with themes taken from poems and stories, the calligraphic characters are frequently presented as designs to be enjoyed in their own right. Likewise, the source and meaning of the writing on this dress are obscure, rendering the characters elements of pure design.

Mori had her first foreign show in New York in 1965. From the outset she incorporated designs deliberately evocative of traditional Japanese beauty into Western garments, which brought her attention from Western media. In 1977 she was the first East Asian to be invited to the Paris haute couture fashion week, and the iconic piece that she presented at that time—also bearing ink painting and calligraphic designs—came to represent her signature style. —NT

Fig. 1
Katarai of the Ōgiya, probably from the series *Models for Fashion: New Year Designs as Fresh as Young Leaves*, about 1776–1781. By Isoda Koryūsai (Japanese, 1735–1790). Japan, Edo period (1615–1868). Woodblock print; ink and colors on paper; H 32.3 cm x W 21.7 cm. Museum of Fine Arts, Boston, *William S. and John T. Spaulding Collection*, 21.8251.

Cat. 35

Evening dress

By Rei Kawakubo (Japanese, b. 1942)
Comme des Garçons, Autumn/Winter
1991
Label: Comme des Garçons Noir
Silk taffeta with hand painting
Design featuring a flying-cranes motif
and a red wadded hem
*Collection of The Kyoto Costume
Institute*, Inv. AC7076 92-7-4AB
Shown at AAMSF, CAM, and Newark

The keywords for the 1991 Comme
des Garçons Noir collection were
"chic punk," "vinyl," and "*noir*,"
or black. Evening dresses with
Japanese associations formed
the finale of this collection and
included this piece, in which a
yūzen (traditional dyeing technique)
painter freely drew an avian design
on this Western-style crinoline-like
skirt. Said Kawakubo: "I wanted to
juxtapose the very naïve, almost
childlike brushstrokes with the very
formal evening dress."[2] Inserting
kimono-style cotton padding into
the hem of the underdress lends the
dress a certain élan while also giving
it just enough weight to preserve its
silhouette. Here Kawakubo blends
the traditional beauty of East and
West to create a new idiom and,
in so doing, stimulates aesthetic
awareness and demonstrates the
designer can draw inspiration from
whatever interests her. — TS

Cat. 36

Dress

By John Galliano (British, b. 1960)
Christian Dior, Spring/Summer 2001
Label: Christian Dior Boutique Paris
Silk jacquard with printing, cotton
tulle, vinyl, leather, and metal
Design featuring motifs of oxcart
wheels (*Genji guruma*), plum
blossoms, and chrysanthemums
over a pattern of roses and possibly
Japanese women

*Collection of The Kyoto Costume
Institute,* Inv. AC10446 2001-5
Shown at CAM and Newark

This revealing design brims with
playfulness and incorporates layers
of imagery associated with Japanese
elegance. The asymmetric skirt
and the halter neck attached to the
bodice emphasize the beauty of
the low-cut neckline. The zip details
at the chest and hip and the vinyl
material on the bodice add a modern
feel. Traditional Japanese designs—
chrysanthemums, plums, and oxcart
wheels—are printed on white silk
with woven patterns of roses and
perhaps women standing on a
balcony. The impressionistic design
is reminiscent of mid-nineteenth-
century *kosode*. Western artists of
that time, such as Jacques-Joseph
James Tissot (see cat. 1), sometimes
included *kosode*—either worn by
women or as room decor—in their
paintings to conjure a voluptuous
and exotic mood. Conveying the
same sensuality nineteenth-century
painters saw in kimono, Galliano
skillfully expresses an evocative
notion of femininity. — TS

Cat. 37

Jumpsuit and harness

By Sarah Burton (British, b. 1974)
Alexander McQueen, Spring/Summer
2015
Label: Alexander McQueen
Jumpsuit: silk twill with printing;
harness: snake leather
Wide-sleeved design featuring motifs
of waves and cherry blossoms
*Collection of The Kyoto Costume
Institute*, Inv. AC13223 2015-14AB
Shown at AAMSF, CAM, and Newark

This combination of an elegant feminine textile—waves and cherry blossoms rendered in black, red, and pink—with a masculine harness suggestive of samurai armor has an androgynous and unsettling magnetism typical of Alexander McQueen. Between 1992, when his line was established, and 2000, when it joined the Gucci Group, he received support from Onward Kashiyama, one of Japan's largest apparel corporations. Sarah Burton, who joined McQueen on his many trips to Japan, recollects going with him to buy vintage kimono, as he frequently used kimono and obi in his work.

After McQueen's death in 2010, Burton became creative director. While continuing the distinctive character of the brand—one that somehow balances such contradictory elements as a handsome tailored look, a sense of social unease, Japanese elegance, and eccentric stylistic details—she has injected a more feminine and fanciful flavor into the line.—TS

Fig. 1
Alexander McQueen Spring/Summer
2015 fashion show, Paris.

Cat. 38

Coat

By Alessandro dell'Acqua (Italian, b. 1962)
Rochas, Autumn/Winter 2015
Label: Rochas
Coat: wool and silk twill with beaded velvet appliqué; tie: wool twill
Design featuring a swallow motif

Collection of The Kyoto Costume Institute, Inv. AC13261 2015-29-1AB
Shown at AAMSF, CAM, and Newark

Appliquéd swallows flit about this sky-blue coat, whose couture-style tailoring shows a beautiful straight line. This heavy-weight, full-bodied twill coat was made for the ninetieth anniversary of the Rochas fashion house. The swallow motif is based on a dress presented by Marcel Rochas in 1934, a photo of which appeared in *Femina* magazine in June of that year.

This motif is often seen on paper stencils (*katagami*) for Japanese kimono (see fig. 1), which in turn were included in Japanese design anthologies published in the West in the late nineteenth and early twentieth centuries. The swallow motif was widely used by textile manufacturers in Lyon at that time, a fact seemingly referenced in this design.

Established as an haute couture house in 1925, Rochas developed a style that merged innovation and elegance—as when it fostered the fashion of wide shoulder lines in the 1930s. It now specializes in ready-to-wear garments. Dell'Acqua became creative director with the autumn and winter collection of 2014. — NT

Fig. 1
Seven swallows stencil, approx. 1800–1900. Japan. Edo (1615–1868) or Meiji (1868–1912) period. Paper laminated with persimmon tannin; H. 41 cm x W. 57.1 cm. *Asian Art Museum of San Francisco, Bequest of Frank D. Stout*, F1998.40.7. Shown at AAMSF.

Cat. 39

Jacket, T-shirt, and trousers

By Raf Simons (Belgian, b. 1968)
Raf Simons, Spring/Summer 2015
Label: Raf Simons
Jacket: cotton/polyester/polyurethane-
blend twill and rayon twill with printing;
T-shirt: cotton jersey with printing;
trousers: polyester twill
Design featuring ukiyo-e–like images
on the large jacket collar and stylized
chrysanthemums and an astronaut
image on the T-shirt

*Collection of The Kyoto Costume
Institute*, Inv. AC13195 2015-1,
AC13196 2015-2, AC13197 2015-3-1
Shown at Newark

The black rectangular collar of this
bright red jacket reaches down
to the waist in the back. On it are
displayed graphic transfers of a
photo of a woman emerging from the
water and the ukiyo-e motif known
as "Red Fuji," which recalls the work
of the Edo-period artist Katsushika
Hokusai (fig. 1). The T-shirt that is
part of this ensemble has Japanese
chrysanthemum motifs printed in a
checkerboard pattern and a photo
of astronauts. Taken together, this
outfit becomes a collage of the
designer's personal recollections:
favorite movies and art and photos
of his friends and family. In this way
Simons extends the long-honored
Japanese practice of incorporating
shared cultural memories—pictures,
poems, scenes from classics—as
patterns on clothing. Displayed
most emblematically on the men's
underrobes called *juban* and the
linings of kimono-style coats (*haori*),
these meaningful images hidden in
intimate places struck the Japanese
as playful and flirtatious and were
part of the style they called *iki* (chic).

Simons established his own
brand of menswear in 1995. He
is known for weaving elements of
street culture and modern art into his
minimal designs. —MI

Fig. 1
South Wind and Clear Sky, from the
series *Thirty-Six Views of Mount Fuji*. By
Katsushika Hokusai (Japanese, 1760–
1849). Japan, Edo period (1615–1868).
Woodblock print; ink and colors on
paper; H. 26.6 cm x W. 38.1 cm. *Newark
Museum Purchase 1951 Wallace M.
Scudder Bequest Fund*, 51.131. Shown
at Newark.

Cat. 40

Top and dress

By Rei Kawakubo (Japanese, b. 1942)
Comme des Garçons, Spring/Summer
1983
Label: Comme des Garçons Noir
Top: cotton jersey with cotton ribbon;
dress: cotton sheeting with rayon satin
patching
Oversized design with an emphasis
on the appearance of distressed and
ragged qualities through patchwork,
tears, and creases
*Collection of The Kyoto Costume
Institute*, Inv. AC7801 93-24-9AB, gift
of Comme des Garçons Co., Ltd.
Shown at CAM

With its asymmetrical construction
and ragged style, this distinctive
piece is representative of
Kawakubo's works from the 1980s.
It is made from an assortment of
unbleached and totally wrinkled
fabrics, some of which are
deliberately torn. When the collection
debuted in Paris, it was built
around monotone colors, including
unbleached natural tones, but
featured numerous pieces where
black created a strong impact.

The patchwork and joined ribbons
on this dress make it appear as if it
were an old threadbare garment that
has seen repeated repairs, evoking
a sense of antiquated charm. In
addition, one can see the Japanese
aesthetic of imperfection in the
unbleached fabrics and unsewn
areas. In his *Essays in Idleness* the
fourteenth-century writer Yoshida
Kenkō (approx. 1284–1350) said,
"In everything, no matter what it
may be, uniformity is undesirable.
Leaving something incomplete
makes it interesting, and gives one
the feeling that there is room for
growth."[3] The Japanese ethos that
seeks beauty in the imperfect lives
on in such practices as *chanoyu*
(the tea ceremony) and *kadō* (flower
arranging). This piece might be seen
as incorporating multiple layers of
this aesthetic. —NT

Cat. 41

Dress and T-shirt

By Rei Kawakubo (Japanese, b. 1942)
Comme des Garçons, Autumn/Winter
1984
Label: Comme des Garçons
Dress: rayon plain weave with printing;
T-shirt: rayon plain weave with printing
Design featuring a chrysanthemum
pattern inspired by *katazome* prints
*Collection of The Kyoto Costume
Institute*, Inv. AC7914 93-24-122AB,
gift from Comme des Garçons Co., Ltd.
Shown at AAMSF and Newark

This ensemble revives traditional stencil-dyed (*katazome*) indigo, only on modern textiles rather than cotton. This *aizome* (indigo dyeing) technique spread through Japan with cotton weaving during the Edo period (1615–1868). Japanese indigo is an immersion dye suitable for several dyeing methods, including stencil (see figs. 1 and 2) and bind-resist (*shibori*) dyeing. In the nineteenth century, when stencil-dyed indigo was most popular, numerous types and styles of patterns were devised for both everyday wear and clothes for special occasions. With this piece Kawakubo updates two such motifs—chrysanthemums and scrolling vines—for modern times in *shibori* and *sashiko* (straight-stitch pattern quilting). She deconstructs past traditions and techniques and freely recombines them, making it clear that she sees no boundary between tradition and the vanguard and demonstrating a broad vision of materials.—NT

Fig. 1
Chrysanthemum-motif stencil. Japan, Edo period (1615–1868). Paper laminated with persimmon tannin; H. 31.1 cm x W. 41.3 cm. *Newark Museum Gift of Leon Dabo, 1926*, 26.566. Shown at Newark.

Fig. 2
Chrysanthemum-motif stencil. Japan, Edo period (1615–1868). Paper laminated with persimmon tannin; H. 24.8 cm x W. 41.9 cm. *Newark Museum Gift of Leon Dabo, 1926*, 26.538. Shown at Newark.

Cat. 42

Jacket, shirt, and trousers

By Junya Watanabe (Japanese, b. 1961)
Junya Watanabe Comme des Garçons, Spring/Summer 2015
Label: Junya Watanabe Comme des Garçons Man
Jacket: Multiple fabric types (approximately fifteen) including cotton, wool, linen, rayon, and polyester; shirt: cotton plain weave; trousers: multiple types of cotton and linen (approximately fifteen)
Jacket and trouser design featuring patchwork with hand stitching inspired by *boro*; check-patterned shirt
Collection of The Kyoto Costume Institute, Inv. AC13199 2015-4-1AE
Shown at AAMSF, CAM, and Newark

Cat. 43

Boro/dotera

Japan, Meiji period (1868–1912)
Cotton plain weave, handwoven and indigo dyed
Garment constructed from torn and patched fabric pieces
Collection of The Kyoto Costume Institute, Inv. AC13471 2017-6-1
Shown at AAMSF, CAM, and Newark

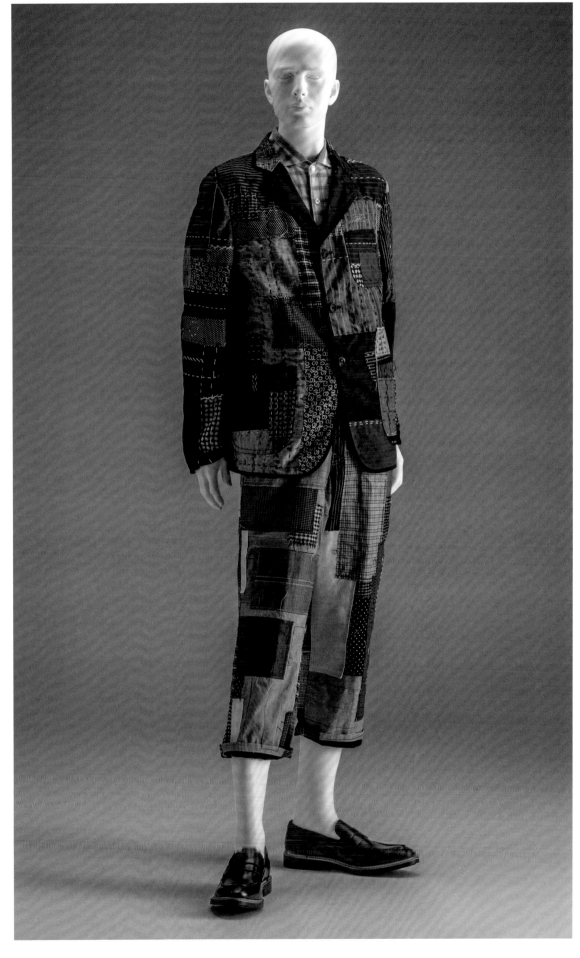

Junya Watanabe's suit is inspired by the traditional daily work clothing of Japanese farmers known as "rag wear" (*boro*), made from scraps of joined and patched cloth. Just as *boro* reused old garments, this piece is an assemblage of fabrics from various production areas, each with a story that chronicles its origin. The jacket employs several textiles, including gabardine and serge, which are often used to make men's suits, while the pants are cotton and linen broadcloth. The warmth and playfulness of this handmade and hand-stitched patchwork echoes contemporary street fashion—while serving as a critique of the modern practice of trashing garments en masse.

Building on his skill in traditional tailoring, Watanabe creates new garment forms by dismantling and reconstructing old ones. Frequently employing patchwork, he skillfully expresses the structural beauty of all kinds of garments. He joined Comme des Garçons Man in 1984 and since 1992 has shown as Junya Watanabe Comme des Garçons Man. —NT

In early modern Japan, ordinary townsfolk provided cultural leadership, unlike Western societies dominated by court culture. This town-dwelling merchant class rose to prominence in the Edo period (1615–1868) as its economic power increased. Both ukiyo-e (woodblock prints, linked to modern manga) and *kibyōshi* (yellow-covered illustrated storybooks for adults) can be considered popular products of this merchants' culture. The populist spirit was also transmitted to dress culture. In a society restricted by the class system, common people decorated clothing that could not be seen in public—for example, the inside of a coat or undergarments—with surprisingly bold designs that we should rightly label "pop."

If popular culture is a leading force in our time, the focus on Japanese manga and animation is perfectly appropriate. Fashion reflects this pop spirit. At the beginning of the twenty-first century, the world was fascinated by young people in Tokyo's Harajuku district who wore colorful outfits as though they had stepped straight out a manga strip; high-end fashion designers followed suit, adding clothing with references to Japanese manga like "Astro Boy" (see cat. 44) to their collections. Just as motifs from kimono have influenced international designers, images from anime, such as *Mobile Suit Gundam* (see cat. 47), have likewise been incorporated into Western clothing. Fashion, liberated from preexisting hierarchies and oblivious to the distinctions between fine art and pop art, is creating unprecedented, innovative graphic design.

Cat. 44

Polo shirts and T-shirts

By Hiroaki Ohya (Japanese, b. 1970)
Lacoste Capsule Collection, Autumn/
Winter 2013
Label: Lacoste L!ve, Osamu Tezuka,
© Tezuka Productions
Polo shirts: cotton knit with printing;
T-shirts: cotton jersey with printing
Designs featuring manga motifs by
Osamu Tezuka (Japanese, 1928–
1989); images from (left) *Kimba,
the White Lion*, shown at AAMSF
and Newark; (top right) *Black Jack*,
shown at AAMSF, CAM, and Newark;
(bottom right) *The Mysterious
Underground Men*, shown at CAM
and Newark; (overleaf top) *Phoenix*,
shown at Newark; and (overleaf
bottom) *Astroboy*, shown at AAMSF,
CAM, and Newark

*Collection of The Kyoto Costume
Institute*, Inv. AC13056 2014-1-1AB,
AC13059 2014-1-4AB, AC13061
2014-1-6AB, AC13064 2014-1-9AB,
AC13007 2014-1-12AB, gift of OHYA
DESIGN STUDIO CO., LTD.

Printed on each of six shirts is a scene from one of Osamu Tezuka's manga, such as *Astroboy*, broadcast in Japan and the United States in 1963, and *Kimba, the White Lion*, winner of the Silver Lion Award at the 1967 Venice International Film Festival. When designing these garments, Ohya chose a scene from six different works by Tezuka—known around the world as a pioneering manga and animation artist—and found inspiration in the artist's own words: "Humans have had three dreams since the dawn of time. One is flight, another is transformation, and the last is communicating with animals."[1] These shirts (five of the six are shown here) were produced while Ohya was head of the Lacoste L!ve line (begun in 2011), which brings street culture to the French sportswear brand. —RN

Cat. 45

Top, collar, skirt, and mask

By Kazuaki Takashima (Japanese, b. 1973)
Né-net, Autumn/Winter 2014
Label: Né-net
Top: cotton/rayon-blend jersey with printing; collar: polyester/cotton-blend plain weave; skirt: cotton/polyester-blend cut jacquard; mask: sequins
Design featuring illustrations of a girl, cat, and bear by manga artist Yumiko Igarashi (Japanese, b. 1951)
Collection of The Kyoto Costume Institute, Inv. AC13154 2014-30A-D, FG, gift of A-net Inc.
Shown at CAM and Newark

This outfit features characters drawn by Yumiko Igarashi, who is famous for the manga *Candy Candy*, published in the late 1970s. Their faces are printed on the top and woven on the skirt. Takashima has worked as a designer for Né-net since 2005 and often uses his own drawings on his garments. For this collection, however, he commissioned Igarashi to do them. A key concept here is *kirakira*, or "sparkle": Takashima has sprinkled the garment with twinkly symbols and the large sparkly eyes characteristic of girls' comics. With its charming figures and garment construction resembling children's wear, this ensemble embodies the Japanese culture of cuteness known as *kawaii*. —RN

Cat. 46

Suit and hat

By Nozomi Ishiguro (Japanese,
b. 1964)
NOZOMI ISHIGURO HAUTE
COUTURE, Spring/Summer 2015
Label: NOZOMI ISHIGURO HAUTE
COUTURE
Wool/polyurethane-blend plain weave
with printing
Design featuring motifs of
onomatopoeia frequently appearing in
Japanese manga
*Collection of The Kyoto Costume
Institute*, Inv. AC13184 2014-41AE
Shown at AAMSF, CAM, and Newark

The surfaces of this slim-fitting
men's suit and ten-gallon hat are
entirely covered with *katakana*:
onomatopoeic words frequently used
in Japanese manga to express, for
example, sounds of impact (*gon!*
ゴン and *doka!* ドカッ), cutting
(*supa!* スパッ), or running water
(*zaa* ザー). More than just a comic
convention, *katakana* also convey
a powerful sense of reality, as they
echo the sounds of suffering wrought
by the large-scale disasters that
have repeatedly hit Japan. Ishiguro
said they "expressed the various
sounds of screams and explosions
that I heard during the time that I
was making the clothes, as houses
were swept away by floods, and
volcanoes erupted."[2] Employed here
as a graphic-design motif, the sea of
lettering makes it hard to discern the
actual shape of the clothes.

Ishiguro became an independent
designer in 1998, distancing
himself from existing practices with
handmade work that refashioned
used clothing to create garments
with a message.—RN

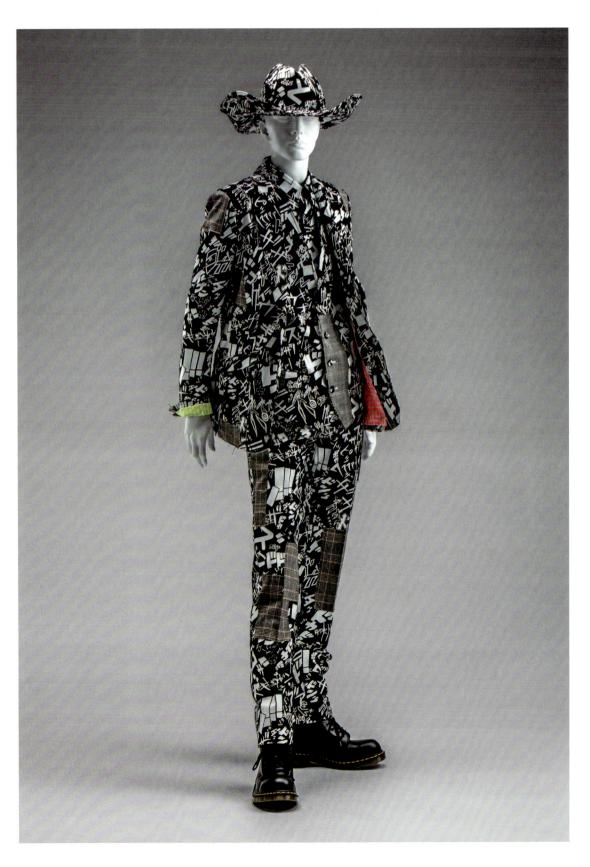

Cat. 47

Tunic, jacket, trousers, and sneakers

By Jonathan Anderson (Irish, b. 1984)
Loewe, Spring/Summer 2016
Label: Loewe
Tunic: wool/nylon-blend jacquard
jersey; jacket: nylon gauze; trousers:
cow leather; sneakers: cow leather
with printing
Design featuring robot motifs from the
anime *Mobile Suit Gundam*

*Collection of The Kyoto Costume
Institute*, Inv. AC13382 2016-6AE
Shown at AAMSF, CAM, and Newark

Here a jersey-fabric tunic with a
jacquard weave robot motif is
combined with leather trousers. The
robot is a character from the cult
Japanese anime *Mobile Suit Gundam*
(1979). The formality of the tunic,
often part of police and military
uniforms, has been transformed
by the addition of lighthearted
features like a left-over-right front
opening often used in women's
wear, U-shaped slits at the wrist to
create a loose cuff flap, and large
round patch-pockets as seen on
children's wear.

Loewe is a world-renowned
luxury brand based in Spain that
has focused on leather goods since
1846. Its high-quality techniques are
evident here in the paper-thin tanned
leather trousers, while the playful
tunic gives the brand a contemporary
image. Jonathan Anderson, Loewe's
creative director since 2015, has a
keen interest in Japanese style, as
seen in the series of judo trousers in
his collection.—RN

CHECKLIST OF THE EXHIBITION

Kimono in Paintings

Young Women Looking at Japanese Articles, 1869
By Jacques-Joseph James Tissot
(French, 1836–1902)
Oil on canvas
H. 70.5 cm x W. 50.2 cm
Cincinnati Art Museum, Gift of Henry M. Goodyear, MD, 1984.217
Shown at AAMSF, CAM, Newark
Cat. 1

Girl in a Japanese Costume, approx. 1890.
By William Merritt Chase
(American, 1849–1916)
Oil on canvas
H. 62.5 cm x W. 39.8 cm
Brooklyn Museum, Gift of Isabella S. Kurtz in memory of Charles M. Kurtz, 86.197.2
Shown at AAMSF, CAM, Newark
Cat. 2

Long-sleeved kimono (*furisode*),
mid-1800s
Japan, Edo period (1615–1868)
Silk crepe with printing or stenciling, silk-floss embroidery, and gold-thread couching
Design featuring motifs of cherry trees, peonies, hills, waterfalls, clouds, and lion-dogs (*komainu*)
Cincinnati Art Museum, Gift of Edward Senior, 1974.16
Shown at CAM
Cat. 3

The Mirror, approx. 1900
By William Merritt Chase
(American, 1849–1916)
Oil on canvas
H. 91.4 cm x W. 73.7 cm
Cincinnati Art Museum, Museum Purchase, 1901.44
Shown at CAM

Long-sleeved kimono (*furisode*),
1800–1900
Japan, Edo (1615–1868) or Meiji period (1868–1912)
Silk crepe and silk brocade with discharge printing, direct printing, and hand painting
Crepe exterior embellished with cherry-blossom, water-plant, and water motifs; padded brocade interior featuring a floral motif over an endless-key pattern, with one gore in a design of flying plover and red rings
Newark Museum Purchase 1929 29.4
Shown at Newark

Woman's kimono with butterfly and floral motifs, before 1929
Japan, Taishō period (1912–1926), for export market
Silk crepe with discharge printing and direct printing; silk lining
Design featuring spider and daisy chrysanthemums, flowering tobacco, strawberry, tulip, woodruff, and grapevine motifs with three-aoi-leaf crests, with a lining of pink "China" silk (*habotai*)
Newark Museum Purchase 1929, 29.3A,B
Shown at Newark

Summer robe, 1800–1850
Japan, Edo period (1615–1868)
Ramie and silk, paste-resist (*yūzen*) dyed, with stenciling, silk embroidery, and metal-wrapped-thread couching; hemp lining
Design featuring a winter scene of an imperial cart (*gosho guruma*), a rustic villa, fishing nets, and a harp, interspersed with dot patterns (*katabitta*)
Asian Art Museum of San Francisco, Gift of John C. Weber, 2017.19
Shown at AAMSF

Japonism in Fashion

Kimono as Dress

Dress, 1876–78
Turner
Label: Misses Turner Court Dress Makers, 151 Sloane Street, London
Bodice and overskirt: silk satin damask (*rinzu*) with silk and metallic-thread embroidery
Design featuring wisteria, chrysanthemum, peony, and Chinese-fan motifs
Collection of The Kyoto Costume Institute, Inv. AC8938 93-28-1AB
Shown at AAMSF, CAM, and Newark
Cat. 4

Kimono, approx. 1800–1868
Japan, Edo period (1615–1868)
Silk satin damask (*rinzu*) with silk and
metallic-thread embroidery
Design featuring wisteria,
chrysanthemum, peony, oxcart-wheel,
and maze-pattern motifs
*Collection of The Kyoto Costume
Institute*, Inv. EQ257
Shown at AAMSF, CAM, and Newark
Cat. 5

Japonism in Fashion

Japanese Motifs

Ball gown, approx. 1888
House of Rouff
Label: Paris Rouff Paris
Two-piece dress; silk satin with sequins
and silver-thread embroidery
Brocaded train featuring plant (possibly
fern) patterns
*Collection of The Kyoto Costume
Institute*, Inv. AC7068 92-5-3AB
Shown at AAMSF, CAM, and Newark
Cat. 6

Coat (visite), approx. 1890
Possibly House of Worth
Cashmere twill with silk appliqué and
feathers
Design featuring samurai-helmet
(*kabuto*), folding-fan, and cherry-
blossom motifs on the front, collar,
back, and back slit
*Collection of The Kyoto Costume
Institute*, Inv. AC5367 86-17-7B
Shown at CAM and Newark
Cat. 7

Day dress, approx. 1897
By Jacques Doucet
(French, 1853–1929)
Doucet
Label: Doucet
Two-piece dress with belt; wool twill,
silk satin, and silk chiffon with appliqué
and enamel
Design featuring Japanese iris
(*kakitsubata*) motifs on the shoulders,
sleeves, and hem
*Collection of The Kyoto Costume
Institute*, Inv. AC10426 2001-1-2ACB
Shown at AAMSF, CAM, and Newark
Cat. 8

***Mitate* of the story of Ōta Dōkan**,
1766–1767
By Suzuki Harunobu
(Japanese, approx. 1725–1770)
Japan, Edo period (1615–1868)
Woodblock print; ink and colors on
paper
H. 27.9 cm x W. 20.3 cm
*Asian Art Museum of San Francisco,
Gift of the Grabhorn Ukiyo-e Collection,*
2005.100.28
Shown at AAMSF
Cat. 8, fig. 1

Textile, approx. 1889
J. Béraud & Cie, Lyon, France
Silk satin with broché, lancé, and liseré
patterning
Design featuring morning-glory and
grass motifs
H. 153 cm x W. 66 cm (overall); H.
49.5 cm x W. 61 cm (pattern repeat)
*Collection of The Kyoto Costume
Institute*, Inv. AC7601 92-23-9
Shown at CAM and Newark
Cat. 9

Textile, approx. 1912
France
Silk damask with broché patterning
Design featuring wave patterns
H. 173 cm x W. 95 cm (overall); H.
34 cm x W. 23.5 cm (pattern repeat)
*Collection of The Kyoto Costume
Institute*, Inv. AC937 93-27-3
Shown at CAM and Newark
Cat. 10

Evening coat, approx. 1910
Possibly France
Gold damask lamé, silk velvet, and fur
with metallic lace and metallic and silk
cord
Design featuring floral motifs with
dolman sleeves and knotted tassels
*Cincinnati Art Museum, Gift of William
Mack, 1943.25*
Shown at CAM
Cat. 11

Evening dress, approx. 1913
Possibly House of Worth
Silk tulle and silk satin with bead
embroidery
Design featuring Japanese motifs
on both the train and the tunic-style
double-layered front bodice
*Collection of The Kyoto Costume
Institute*, Inv. AC7764 93-18-5
Shown at CAM
Cat. 12

**Courtesans and *kamuro* viewing
plum blossoms**, approx. 1787–1801
By Katsukawa Shunchô (Japanese,
active approx. 1780–1801)
Japan, Edo period (1615–1868)
Woodblock print; ink and colors on
paper: right and middle sheets of
triptych
H. 38.1 cm x W. 24.8 cm each
*Newark Museum Purchase 1909
George T. Rockwell Collection*, 9.1471,
9.1472
Shown at Newark

Japonism in Fashion
Dressing Gowns

Dressing robe, 1874–1876
Japan, Meiji period (1868–1912)
Silk plain weave, quilted, with twisted-
silk embroidery
Design featuring floral motifs on
the stand-up collar, patch pockets,
cuffs, center front opening, and upper
back, with frog-shaped closures and a
slight train
*Cincinnati Art Museum, Gift of Mr.
and Mrs. Russell S. Sims in memory of
Margaret Minor Shaffer, 1989.13*
Shown at CAM

Kimono and sash, approx. 1920
Japan, Taishō period (1912–1926)
Silk crepe damask with twisted-silk
embroidery and silk fringe
Design featuring floral-patterned
fabric and embroidery, and a sash with
knotted fringe
*Cincinnati Art Museum, Gift in
memory of Mrs. William Leo Doepke
(Ethel Page) by her granddaughter,
Sara Doepke, 2012.95a,b*
Shown at CAM

Japanese Kimono, 1915
By Richard Miller
(American, 1875–1943)
Oil on canvas
H. 100.3 cm x W. 81.3 cm
*Cincinnati Art Museum, Annual
Membership Fund, 1915.486*
Shown at CAM

Japonism in Fashion
Kimono Form

Evening dress, approx. 1910
By Lucy Duff-Gordon
(British, 1863–1935)
Lucile Ltd.
Label: Lucile Ltd., 17 West 36th Street,
New York
Dress: silk cut velvet, silk twill, and silk
organdy; sash: silk twill; corsage: lamé
Design in a wave-patterned fabric
featuring kimono sleeves, obi-like sash,
and train
*Collection of The Kyoto Costume
Institute*, Inv. AC13153 2014-29AB
Shown at AAMSF, CAM, and Newark
Cat. 13

Washday, 1788
By Torii Kiyonaga
(Japanese, 1752–1815)
Japan, Edo period (1615–1868)
Woodblock print; ink and colors
on paper
H. 38 cm x W. 25.4 cm (each)
*Asian Art Museum of San Francisco,
Gift of the Grabhorn Ukiyo-e Collection*,
2005.100.68.a-.c
Shown at AAMSF
Cat. 13, fig. 1

Coat, approx. 1910
By Jean-Philippe Worth
(French, 1856–1926)
House of Worth
Label: C Worth, 24200 (stamp)
Velvet with beading
Cocoon-shaped design with a pulled-
back collar and loose drapes at the
lower back
*Collection of The Kyoto Costume
Institute*, Inv. AC2880 79-27-1
Shown at CAM

Evening coat, 1910
By Georges Doeuillet
(French, 1865–1934)
Doeuillet
Label: Doeuillet, 18 Place Vendome,
Paris
Silk chiffon, cotton lace, and silk velvet
Design embellished with machine-
made lace and velvet ribbons
*Cincinnati Art Museum, Gift of Phillip
and Whitney Long, 2008.112*
Shown at CAM

Evening coat, approx. 1913
House of Amy Linker
Label: Amy Linker, Linker & Co.
Sps., 7 Rue Auber, Paris 010070
(handwritten)
Silk satin and silk crepe with bead
embroidery
Design featuring a pulled-back striped
collar and loose drapes, embellished
with floral and Asian motifs
*Collection of The Kyoto Costume
Institute*, Inv. AC3775 81-8-1
Shown at AAMSF, CAM, and Newark
Cat. 14

Dress, 1920–1930
By Paul Poiret (French, 1879–1944)
The House of Paul Poiret
Dress and belt: silk crepe, tie-dyed,
with stenciling
Design inspired by *haori*, with
traditional Japanese motifs
*Collection of The Kyoto Costume
Institute*, Inv. AC11551 2006-17-1AB
Shown at AAMSF, CAM, and Newark
Cat. 15

Evening dress, 1927–1928
By E. L. Mayer (American, active early
1900s)
E. L. Mayer Inc. (1905–1931)
Label: E. L. Mayer, New York
Silk chiffon and silk crepe
Draped design with kimono sleeves
and twisted attached belt
*Cincinnati Art Museum, Gift of Dorette
Kruse Fleischmann in memory of Julius
Fleischmann, 1991.200*
Shown at CAM

Evening coat, approx. 1910
Attributed to Liberty & Co.
(British, est. 1875)
Silk satin with twisted-silk embroidery
and silk cord
Design featuring kimono-like sleeve
openings and floral-patterned
embroidery
*Cincinnati Art Museum, Gift of Mrs.
Stanley M. Straus, 1967.114*
Shown at CAM

Coat, 1920–1925
By Miss Lillie
(American, active early 1900s)
Miss Lillie
Label: Miss Lillie, 2114 Walnut St.,
Phila. Pa.
Gold lamé with silk velvet pile and fur
Design featuring a fern-patterned body
with fur collar, cuffs, and hem
*Cincinnati Art Museum, Gift of Mrs.
Frances Lamson Eaton, Mr. and
Mrs. Alfred W. Lamson, Mr. and
Mrs. Benjamin Whitney Lamson, Jr.,
1971.323*
Shown at CAM

Evening coat, approx. 1927
By Gabrielle "Coco" Chanel
(French, 1883–1971)
Chanel
Label: Chanel
Silk crepe with gold brocade
Design featuring a chrysanthemum
motif and padded cuffs
*Collection of The Kyoto Costume
Institute*, Inv. AC9182 94-45
Shown at AAMSF, CAM, and Newark
Cat. 16

Standing beauty
Japan, Meiji period (1868–1912)
Bronze
H. 36.2 cm x W. 12.7 cm x D. 12.7 cm
*Newark Museum, Gift of Alice Roff
Estey, 1920, 20.751*
Shown at Newark

Japonism in Fashion

Straight Cutting

Komachi at Sekidera Temple: Koimurasaki of the Tamaya, from *Fashionable Seven Komachi*, approx. 1814–1817
By Kikukawa Eizan (Japanese, 1787–1867)
Edo period (1615–1868)
Woodblock print; ink and colors on paper
H. 38.1 cm x W. 24.8 cm
Newark Museum Purchase 1909
George T. Rockwell Collection, 9.1652
Shown at Newark

Poem by Fujiwara Nakafumi, from an untitled series of *Thirty-Six Immortal Poets*, approx. 1767–1768
By Suzuki Harunobu (Japanese, 1725–1770)
Edo period (1615–1868)
Woodblock print; ink and colors on paper
H. 28.6 cm x W. 20.9 cm
Newark Museum Purchase 1909
George T. Rockwell Collection, 9.1407
Shown at Newark

Wedding dress, 1922
By Madeleine Vionnet
(French, 1876–1975)
Vionnet
Label: Madeleine Vionnet, No. 14053 (stamp), 4490 (handwritten), fingerprint stamp
Silk faille with silk tulle embellishments
Straight-cut design with a puffed bow at the back and rose embellishments by Lesage on the train
Collection of The Kyoto Costume Institute, Inv. AC7007 91-15-3A
Shown at AAMSF, CAM, and Newark
Cat. 17

Evening dress "Henriette"
By Madeleine Vionnet
(French, 1876–1975)
Vionnet, Winter 1923
Label: Madeleine Vionnet, No. 26288 (stamp), fingerprint stamp
Gold and silver lamé plain weave, pieced
Design featuring a geometric patchwork pattern
Collection of The Kyoto Costume Institute, Inv. AC6819 90-25A, Gift of Mr. Martin Kamer
Shown at AAMSF, CAM, and Newark
Cat. 18

Evening coat, approx. 1925
By Edward Molyneux
(British, 1891–1974)
Molyneux
Label: Molyneux, 314 Gold & Blue Metal 1/3, B. Altman & Co., Paris, New York
Gold lamé with hand painting and silk crepe
Knee-length design featuring a floral motif with wide shirred sleeves, attached scarf, and blue lining
Cincinnati Art Museum, Gift of Mrs Harold J. Kersten, 1967.572
Shown at CAM

Dress, 1925–1928
United States
Silk crepe and silk satin with glass-bead embroidery
Straight-cut design with floral pattern
Cincinnati Art Museum, Gift of Joseph E. Holliday, 1970.43
Shown at CAM

Kimono in Contemporary Fashion

Flatness

Rhythm Pleats Dress
By Issey Miyake (Japanese, b. 1938)
ISSEY MIYAKE, Spring 1990
Label: ISSEY MIYAKE
Polyester and linen, pleated
Design featuring a flat circular shape, three-quarter-length sleeves, and a horizontal neck opening
Cincinnati Art Museum, Museum Purchase with funds provided by Friends of Fashion, 2007.109
Shown at CAM
Cat. 19

Dress
By Issey Miyake (Japanese, b. 1938) and Reality Lab
132 5. ISSEY MIYAKE, Spring/ Summer 2011
Label: 132 5. ISSEY MIYAKE
Recycled polyester plain weave with printing
Design featuring black fold lines
Collection of The Kyoto Costume Institute, Inv. AC12462 2010-28-3
Shown at AAMSF, CAM, and Newark
Cat. 20

Dress
By Issey Miyake (Japanese, b. 1938)
and Reality Lab
132 5. ISSEY MIYAKE, Spring/
Summer 2011
Label: 132 5. ISSEY MIYAKE
Recycled polyester plain weave with
printing
Design featuring black fold lines
*Collection of The Kyoto Costume
Institute*, Inv. AC12463 2010 28-4
Shown at AAMSF, CAM, and Newark
Cat. 21

Jacket, skirt, and socks
By Rei Kawakubo (Japanese, b. 1942)
Comme des Garçons
Label: Comme des Garçons, Fall 2012
Jacket and skirt: polyester felt; socks:
cotton knit
Jacket featuring a notched collar,
long sleeves, and a flare at the hips;
rectangular skirt featuring camouflage
and floral motifs
*Cincinnati Art Museum, Museum
Purchase: Lawrence Archer Wachs
Trust, The Cynthea J. Bogel Collection,
2016.247a-d*
Shown at CAM

Dress
By Yoshiyuki Miyamae (Japanese,
b. 1976)
ISSEY MIYAKE, Autumn/Winter 2014
Label: ISSEY MIYAKE
Polyester/triacetate/polyurethane-
blend jacquard, pleated
Design using the 3D Steam Stretch
technique
*Collection of The Kyoto Costume
Institute*, Inv. AC13137 2014-21-5B
Shown at AAMSF, CAM, and Newark
Cat. 22

Dress
By Yoshiyuki Miyamae (Japanese,
b. 1976)
ISSEY MIYAKE, Autumn/Winter 2014
Label: ISSEY MIYAKE
Polyester/triacetate/polyurethane-
blend jacquard, pleated
Design using the 3D Steam Stretch
technique
*Collection of The Kyoto Costume
Institute*, Inv. AC13135 2014-21-3A
Shown at AAMSF, CAM, and Newark
Cat. 23

Dress
By Rei Kawakubo (Japanese, b. 1942)
Comme des Garçons, Spring/Summer
2014
Label: Comme des Garçons
Cotton plain weave
Flat design overlaid with an abstract
motif
*Collection of The Kyoto Costume
Institute*, Inv. AC13089 2014-6-4A
Shown at Newark
Cat. 24

Kimono in Contemporary Fashion

Kimono Silhouette

"Kabuki" dress
By Rudi Gernreich (American,
b. Austria, 1922–1985)
Harmon Knitwear, Autumn 1963
Label: Rudi Gernreich Design for
Harmon Knitwear
Wool jacquard knit
Check-patterned fabric with a V-neck
and obi-like trimming
*Collection of The Kyoto Costume
Institute*, Inv. AC9186 95-3
Shown at AAMSF, CAM, and Newark
Cat. 25

Left:
Ensemble
By John Galliano (British, b. 1960)
John Galliano, Autumn/Winter 1994
Label: John Galliano Paris
Jacket: silk organza; belt: acetate satin
Double-breasted jacket with tied-back
triangular sleeves and an obi-like belt
*Collection of The Kyoto Costume
Institute*, Inv. AC9115 94-12-1,
AC9116 94-12-2
Shown at AAMSF, CAM, and Newark

Right:
Ensemble
By John Galliano (British, b. 1960)
John Galliano, Autumn/Winter 1994
Label: John Galliano Paris
Jacket: wool plain weave; belt: acetate
satin and silk lace
Double-breasted jacket with a train and
obi-like belt
*Collection of The Kyoto Costume
Institute*, Inv. AC9119 94-12-5,
AC9120 94-12-6
Shown at CAM and Newark
Cat. 26

Jacket
By Tom Ford (American, b. 1961)
Gucci, Spring/Summer 2003
Label: Gucci
Rayon tricot with printing; silk tricot
lining
Design featuring chrysanthemum and
Japanese family-crest motifs, long
kimono sleeves, and an attached collar
*Collection of The Kyoto Costume
Institute*, Inv. AC10904 2003-10
Shown at AAMSF and Newark
Cat. 27

Summer kimono, 2013
By Kunihiro Morinaga (Japanese,
b. 1980)
mitasu+ANREALAGE
Label: ANREALAGE
Cotton plain weave with irregular-grid
ribbing
Men's summer kimono redesigned with
feminine long sleeves and a pulled-
back collar
*Collection of The Kyoto Costume
Institute*, Inv. AC13124 2014-17AI
Shown at CAM

Kimono in Contemporary Fashion

Obi Fabric

Dress, 1956
By Toshiko Yamawaki (Japanese,
1887–1960)
Silk taffeta with Japanese gold-
thread embroidery
Design featuring a wave motif
*Collection of The Kyoto Costume
Institute*, Inv. AC12555 2011-8-35AB,
gift from Yamawaki Fashion Art College
Shown at AAMSF, CAM, and Newark
Cat. 28

Dress
By Yohji Yamamoto (Japanese, b. 1943)
Yohji Yamamoto, Spring/Summer 1995
Label: Yohji Yamamoto
Silk/rayon-blend jersey and polyester/
rayon/nylon-blend brocade
Design featuring a chrysanthemum
motif
*Collection of The Kyoto Costume
Institute*, Inv. AC9166 94-34
Shown at AAMSF, CAM, and Newark
Cat. 29

Obi sashes
Japan, Edo period (1615–1868)
Silk continuous-weft brocade with
gold-wrapped threads
Design featuring various crests (*mon*)
and lion (*shishi*) motifs
H. 149.9 cm x W. 45.7 cm each
*Newark Museum, Gift of Herman A.
E. Jaehne and Paul C. Jaehne, 1941,
41.1308A-E*
Shown at Newark

Obi, 1800–1850
Japan, Edo period (1615–1868)
Silk damask
Design featuring floral-patterned
medallions surrounded by interlocking
lines
H. 43.2 cm x W. 302.3 cm
*Cincinnati Art Museum, Gift of the
John Herron Art Institute, 1938.63*
Shown at CAM

Kimono in Contemporary Fashion

Shibori Dyeing

Dress
By Rei Kawakubo (Japanese, b. 1942)
Comme des Garçons, Spring/Summer
1983
Label: Comme des Garçons
Cotton plain weave, bind-resist dyed
(*Miura shibori*)
Kimono-sleeve design with a single-
wrap dot pattern
*Collection of The Kyoto Costume
Institute*, Inv. AC7812 93-24-20, gift of
Comme des Garçons Co., Ltd.
Shown at Newark
Cat. 30

Pullover
By Maurizio Galante (Italian, b. 1963)
Maurizio Galante, Haute Couture
Collection, Autumn/Winter 1994
Label: Maurizio Galante
Silk, tie-dyed (*te-kumo shibori*)
Design featuring a spiderweb binding
pattern
*Collection of The Kyoto Costume
Institute*, Inv. AC9155 94-28AB, gift of
Mr. Maurizio Galante
Shown at AAMSF, CAM, and Newark
Cat. 31

Dress
By Yohji Yamamoto (Japanese,
b. 1943)
Yohji Yamamoto
Label: Yohji Yamamoto, Spring/
Summer 1995
Silk crepe, tie-dyed (*shibori*)
Straight-cut design with *shibori* details
*Collection of The Kyoto Costume
Institute*, Inv. AC9157 94-30-1
Shown at CAM

Jacket, trousers, and sneakers
By Yusuke Takahashi (Japanese,
b. 1985)
ISSEY MIYAKE MEN, Spring/Summer
2014
Label: ISSEY MIYAKE MEN, ISSEY
MIYAKE INC.
Jacket: wool plain weave and
polyester/polyurethane-blend knit;
trousers: wool plain weave; sneakers:
suede; jacket and trousers clamp-resist
dyed (*itajime shibori*) with hand printing
Design featuring gray wool dyed black
with a blue and red geometric pattern
*Collection of The Kyoto Costume
Institute*, AC 13266 15-32AD
Shown at AAMSF, CAM, and Newark
Cat. 32

Dress
By Iris van Herpen (Dutch, b. 1984)
Iris van Herpen, Haute Couture
Collection, Autumn/Winter 2016
Label: Iris van Herpen
Polyester monofilament organza,
shibori tied, and cotton/elastane-blend
twill
Design featuring Super Organza
(*Ten'nyo no hagoromo*) fabric
*Collection of The Kyoto Costume
Institute*, Inv. AC13436 2016-17
Shown at AAMSF, CAM, and Newark
Cat. 33

***Beauty (Bijin) Wearing a Shibori
Robe***
By Renzen [or Renzan] (Japanese,
1797–1858)
Edo period (1615–1868)
Hanging scroll; ink, colors, and gold on
paper with wood, cloth, and porcelain
mount
Image: H. 100.3 cm x 28.6 cm;
overall: H. 184.2 cm x 31.1 cm
Newark Museum Purchase 1921,
21.480
Shown at Newark

**Bamboo- and plum-decorated
hand-towel rack**
Japan, Edo period (1615–1868)
Lacquer on wood, gold, and copper
alloy
H. 60.9 cm x W. 64.8 cm x D. 25.4 cm
*Newark Museum, Anonymous Gift,
1947*, 47.248
Shown at Newark

***Shibori*-patterned scarf**, before 1931
Japan, Taishō (1912–1926) or
Shōwa (1926–1989) period
Silk, tie-dyed (*shibori*)
Design featuring a paulownia-flower
motif
H. 129.5 cm x W. 35.6 cm
*Newark Museum, Gift of Mrs. John
Cotton Dana, 1931* 31.765
Shown at Newark

Kimono in Contemporary Fashion

Japanese Motifs

Dress, 1972
By Hanae Mori (Japanese, b. 1926)
Hanae Mori
Label: Hanae Mori, Tōkyo
Silk chiffon and silk twill with printing
Layered design featuring motifs of
flowers, streams, rocks, and bamboo
*Cincinnati Art Museum, Gift of Tsuneko
Sadao, 1986.986a*
Shown at CAM

Long-sleeved kimono (*furisode*),
1850–1900
Japan, Meiji period (1868–1912)
Silk satin damask with silk embroidery
and metallic-thread couching
Design featuring a motif of cranes in
flight over a floral pattern
*Cincinnati Art Museum, Gift of Mr. and
Mrs. John J. Emery, 1964.785*
Shown at CAM

Dress
By Hanae Mori (Japanese, b. 1926)
Hanae Mori, Autumn/Winter 1989
Label: Hanae Mori Boutique
Silk chiffon with printing
Design featuring a Japanese
calligraphy motif
*Collection of The Kyoto Costume
Institute*, Inv. AC13457 2016-28
Shown at AAMSF, CAM, and Newark
Cat. 34

Evening dress
By Rei Kawakubo (Japanese, b. 1942)
Comme des Garçons, Autumn/Winter
1991
Label: Comme des Garçons Noir
Silk taffeta with hand painting
Design featuring a flying-cranes motif
and a red wadded hem
*Collection of The Kyoto Costume
Institute*, Inv. AC7076 92-7-4AB
Shown at AAMSF, CAM, and Newark
Cat. 35

Dress
By John Galliano (British, b. 1960)
Christian Dior, Spring/Summer 2001
Label: Christian Dior Boutique Paris
Silk jacquard with printing, cotton
tulle, vinyl, leather, and metal
Design featuring motifs of oxcart
wheels (*Genji guruma*), plum blossoms,
and chrysanthemums over a pattern of
roses and possibly Japanese women
*Collection of The Kyoto Costume
Institute*, Inv. AC10446 2001-5
Shown at CAM and Newark
Cat. 36

Jumpsuit and harness
By Sarah Burton (British, b. 1974)
Alexander McQueen, Spring/Summer
2015
Label: Alexander McQueen
Jumpsuit: silk twill with printing;
harness: snake leather
Wide-sleeved design featuring motifs
of waves and cherry blossoms
*Collection of The Kyoto Costume
Institute*, Inv. AC13223 2015-14AB
Shown at AAMSF, CAM, and Newark
Cat. 37

Coat
By Alessandro dell'Acqua (Italian,
b. 1962)
Rochas, Autumn/Winter 2015
Label: Rochas
Coat: wool and silk twill with beaded
velvet appliqué; tie: wool twill
Design featuring a swallow motif
*Collection of The Kyoto Costume
Institute*, Inv. AC13261 2015-29-1AB
Shown at AAMSF, CAM, and Newark
Cat. 38

Seven swallows, approx. 1800–1900
Japan, Edo (1615–1868) or Meiji
(1868–1912) period
Stencil; paper laminated with
persimmon tannin
H. 41 cm x W. 57.1 cm
*Asian Art Museum of San Francisco,
Bequest of Frank D. Stout*, F1998.40.7
Shown at AAMSF
Cat. 38, fig. 1

Flying plover
Japan, Edo period (1615–1868)
Stencil; paper laminated with
persimmon tannin
H. 44. 5 cm x W. 64.8 cm
Newark Museum Purchase 1917,
17.459
Shown at Newark

Jacket, T-shirt, and trousers
By Raf Simons (Belgian, b. 1968)
Raf Simons, Spring/Summer 2015
Label: Raf Simons
Jacket: cotton/polyester/polyurethane-
blend twill and rayon twill with printing;
T-shirt: cotton jersey with printing;
trousers: polyester twill
Design featuring ukiyo-e–like images
on the large jacket collar and stylized
chrysanthemums and an astronaut
image on the T-shirt
*Collection of The Kyoto Costume
Institute*, Inv. AC13195 2015-1,
AC13196 2015-2, AC13197
2015-3-1
Shown at Newark
Cat. 39

Kimono in Contemporary Fashion

Everyday Kimono

South Wind and Clear Sky*, from the series *Thirty-Six Views of Mount Fuji
By Katsushika Hokusai (Japanese, 1760–1849)
Edo period (1615–1868)
Woodblock print; ink and colors on paper
H. 26.6 cm x W. 38.1 cm
Newark Museum Purchase 1951 Wallace M. Scudder Bequest Fund, 51.131
Shown at Newark
Cat. 39, fig. 1

Short boots
By Christian Louboutin (French, b. 1964)
Christian Louboutin
Label: Christian Louboutin, Autumn/ Winter 2017
Silk grosgrain with silk embroidery and studs
Design featuring motifs of pine, bamboo, plum blossom, and crane, inspired by a *kosode* textile from the late Edo period (mid-1800s)
Collection of The Kyoto Costume Institute, Inv. AC13496 2017-18AB
Shown at AAMSF, CAM, and Newark

Top and dress
By Rei Kawakubo (Japanese, b. 1942)
Comme des Garçons, Spring/Summer 1983
Label: Comme des Garçons Noir
Top: cotton jersey with cotton ribbon; dress: cotton sheeting with rayon satin patching
Oversized design with an emphasis on the appearance of distressed and ragged qualities through patchwork, tears, and creases
Collection of The Kyoto Costume Institute, Inv. AC7801 93-24-9AB, gift of Comme des Garçons Co., Ltd.
Shown at CAM
Cat. 40

Dress and T-shirt
By Rei Kawakubo (Japanese, b. 1942)
Comme des Garçons, Autumn/Winter 1984
Label: Comme des Garçons
Dress: rayon plain weave with printing; T-shirt: rayon plain weave with printing
Design featuring a chrysanthemum pattern inspired by *katazome* prints
Collection of The Kyoto Costume Institute, Inv. AC7914 93-24-122AB, gift from Comme des Garçons Co., Ltd.
Shown at AAMSF and Newark
Cat. 41

Chrysanthemum
Japan, Edo period (1615–1868)
Stencil; paper laminated with persimmon tannin
H. 31.1 cm x W. 41.3 cm
Newark Museum Gift of Leon Dabo, 1926, 26.566
Shown at Newark
Cat. 41, fig. 1

Chrysanthemum
Japan, Edo period (1615–1868)
Stencil; paper laminated with persimmon tannin
H. 24.8 cm x W. 41.9 cm
Newark Museum Gift of Leon Dabo, 1926 26.538
Shown at Newark
Cat. 41, fig. 2

Chrysanthemum
Japan, Edo period (1615–1868)
Stencil; paper laminated with persimmon tannin
H. 25.7 cm x W. 41.3 cm
Newark Museum, Gift of Leon Dabo, 1926 26.541
Shown at Newark

Jacket, shirt, and trousers
By Junya Watanabe (Japanese, b. 1961)
Junya Watanabe Comme des Garçons, Spring/Summer 2015
Label: Junya Watanabe Comme des Garçons Man
Jacket: Multiple fabric types (approximately fifteen) including cotton, wool, linen, rayon, and polyester; shirt: cotton plain weave; trousers: multiple types of cotton and linen (approximately fifteen)
Jacket and trouser design featuring patchwork with hand stitching inspired by *boro*; check-patterned shirt
Collection of The Kyoto Costume Institute, Inv. AC13199 2015-4-1AF
Shown at AAMSF, CAM, and Newark
Cat. 42

Boro/dotera
Japan, Meiji period (1868–1912)
Cotton plain weave, handwoven and indigo dyed
Garment constructed from torn and patched fabric pieces
Collection of The Kyoto Costume Institute, Inv. AC13471 2017-6-1
Shown at AAMSF, CAM, and Newark
Cat. 43

Japan Pop

***Juban* underrobe**, 1928–1936
Japan, Shōwa period (1926–1989)
Rayon plain weave with printing
Design featuring Mickey Mouse,
cityscape, plane, car, and steamship
motifs
*Newark Museum, Gift of the Estate of
Michael Sklar*, 1984, 84.577
Shown at Newark

Coat
By Jean-Charles de Castelbajac
(French, b. 1949)
J C de Castelbajac
Label: J C de Castelbajac, Spring/
Summer 1996
Silk gauze with printing
Design featuring an illustration based
on the woodblock print *Three Beauties
of the Present Day*, approx. 1793,
by Utamaro Kitagawa (Japanese,
1753–1806)
*Collection of The Kyoto Costume
Institute*, Inv. AC9446 97-2A, gift from
Jean-Charles de Castelbajac
Shown at CAM

Polo shirts and T-shirts
By Hiroaki Ohya (Japanese, b. 1970)
Lacoste, Autumn/Winter 2013 capsule
collection
Label: Lacoste LIve, Osamu Tezuka,
© Tezuka Productions
Polo shirts: cotton knit with printing;
T-shirts: cotton jersey with printing
Designs featuring manga motifs by
Osamu Tezuka (Japanese, 1928–
1989); images from (top row, left to
right) *Kimba, the White Lion*, shown
at AAMSF and Newark; *Black Jack*,
shown at AAMSF, CAM, and Newark;
The Mysterious Underground Men,
shown at CAM and Newark; (bottom
row, left to right) *Phoenix*, shown
at Newark; and *Astroboy*, shown at
AAMSF, CAM, and Newark
*Collection of The Kyoto Costume
Institute*, Inv. AC13056 2014-1-1AB,
AC13059 2014-1-4AB, AC13061
2014-1-6AB, AC13064 2014-1-9AB,
AC13067 2014-1-12AB, gift of OHYA
DESIGN STUDIO CO., LTD.
Cat. 44

Top, collar, skirt, and mask
By Kazuaki Takashima (Japanese,
b. 1973)
Né-net, Autumn/Winter 2014
Label: Né-net
Top: cotton/rayon-blend jersey with
printing; collar: polyester/cotton-blend
plain weave; skirt: cotton/polyester-
blend cut jacquard; mask: sequins
Design featuring illustrations of a girl,
cat, and bear by manga artist Yumiko
Igarashi (Japanese, b. 1951)
*Collection of The Kyoto Costume
Institute*, Inv. AC13154 2014-30A-D,
FG, gift of A-net Inc.
Shown at CAM and Newark
Cat. 45

Suit and hat
By Nozomi Ishiguro (Japanese,
b. 1964)
NOZOMI ISHIGURO HAUTE
COUTURE, Spring/Summer 2015
Label: NOZOMI ISHIGURO HAUTE
COUTURE
Wool/polyurethane-blend plain weave
with printing
Design featuring motifs of
onomatopoeia frequently appearing in
Japanese manga
*Collection of The Kyoto Costume
Institute*, Inv. AC13184 2014-41AE
Shown at AAMSF, CAM, and Newark
Cat. 46

Tunic, jacket, trousers, and
sneakers
By Jonathan Anderson (Irish, b. 1984)
Loewe, Spring/Summer 2016
Label: Loewe
Tunic: wool/nylon-blend jacquard
jersey; jacket: nylon gauze; trousers:
cow leather; sneakers: cow leather
with printing
Design featuring robot motifs from the
anime *Mobile Suit Gundam*
*Collection of The Kyoto Costume
Institute*, Inv. AC13382 2016-6AE
Shown at AAMSF, CAM, and Newark
Cat. 47

Coat, 2016
IKKO TANAKA ISSEY MIYAKE
Label: IKKO TANAKA ISSEY MIYAKE
Polyester plain weave with printing
Design featuring images from the
poster *Traditional Japanese Dance*,
1981, by Ikkō Tanaka (Japanese,
1930–2002)
*Collection of The Kyoto Costume
Institute*, Inv. AC13336 2015-40-2A
Shown at CAM

Sandals, 2016
Island Slipper
Label: Takashimaya Chiso Tatsumura
Island Slipper
Silk satin with printing and leather
Design featuring motifs of surfers on
the beach in ink-painting style
*Collection of The Kyoto Costume
Institute*, Inv. AC13377 2016-3-1AB
Shown at Newark

Epigraph

"On ne saurait assez admirer avec quel heureux instinct les Japonais ont compris le rôle du vêtement, son décor, son dessin, sa forme, dans l'air, dans la lumière, dans le cadre de la vie." Translated by Clothilde Schmidt O'Hare from Louis Gonse, *L'art japonais* (Paris: Société Française d'éditions d'art, 1883), 280.

The Kimono Meets the West

The Kyoto Costume Institute would like to thank Dr. Masayoshi Okuyama of the Archaeological Institute of Kashihara, Nara Prefecture, for help in identifying materials for objects in this exhibition. Additional thanks to photographers who contributed works to this catalogue. Takashi Hatakeyama, Richard Haughton, Taishi Hirokawa, Kazumi Kurigami, and Masayuki Hayashi.

1 Whistler collected kimono from the beginning of the 1860s. The French critic Champfleury noted that, of all the buyers of Japanese goods, "a young American painter particularly stood out for his extravagance. Not a day passed without him purchasing a piece of lacquerware, a bronze, or an opulent Japanese robe." Champfleury (Jules François Felix Fleury-Husson), "La Mode des Japonaiseries," *La Vie Parisienne*, November 21, 1886, 862–63. The Goncourt brothers sometimes spoke of kimono in their books; see Edmond de Goncourt and Jules de Goncourt, *Journal: Mémoires de la vie littéraire* (Paris: Laffont, 1989), 729; and Edmond de Goncourt, *La maison d'un artiste* (Paris: Charpentier, 1881), 1:238 and 2:289, 346.

2 The Rijksmuseum in Amsterdam and the Gemeentemuseum in the Hague, among others.

3 James McNeill Whistler, *Rose and Silver: The Princess from the Land of Porcelain*, 1863–65, and *Caprice in Purple and Gold: The Golden Screen*, 1864 (both Freer Gallery of Art, Smithsonian Institution, Washington, DC); Dante Gabriel Rossetti, *The Beloved* (*The Bride*), 1865–66 (Tate, London); James Tissot, *La Japonaise au bain*, 1864 (Musée des Beaux-Arts de Dijon), among others.

4 Princess Bonaparte's coat is preserved in Les musées du Second Empire, Musées nationaux du palais de Compiègne. Examples can also be found in Musée de la mode de la Ville de Paris, Musée des Arts Décoratifs, and other locations.

5 Ernest Chesneau, "Le Japon et l'art japonais," *Journal des Demoiselles*, November 1868, 322.

6 The shape of the *kosode* is virtually identical to that of the *uchikake*. The *kosode* is secured with an obi, and the *uchikake* is worn without an obi over the top of the *kosode*. Both terms were used for kimono in the Edo period.

7 See, for example, these works by Chase: *The Japanese Print*, c. 1888 (Neue Pinakothek, Bayerische Staatsgemäldesammlugen, Munich); *A Comfortable Corner*, c. 1888 (Parrish Art Museum, Water Mill, NY); *Making Her Toilet (At Her Toilet)*, c. 1889, and *Spring Flowers (Peonies)*, c. 1889 (Terra Foundation for American Art, Chicago).

8 *Le Grand Robert de la langue français* records that the term *kimono* was first used in France in 1899. Its first use in English has not been established, but it appeared in Liberty catalogues, for example, in the 1890s.

9 Today the term *kimono* in the West refers first and foremost to the traditional Japanese costume, but it still retains a secondary meaning of a dressing gown.

10 Sadayakko Kawakami's photo appeared on the cover of *Le Theatre* in October 1900.

11 The store, on the avenue de l'Opéra, posted advertisements for the "Kimono Sada Yacco" in *Femina* magazine from around 1903 until December 1911.

12 Advertisements for Babani's "kimono" appeared frequently in *Figaro Mode* around 1905. Examples of the garment are preserved in the Museum of Fine Arts, Boston; the Los Angeles County Museum of Art; and other institutions.

13 Dressing gowns called "kimonos" appeared in the Liberty mail-order catalogue from about 1896 and in the Sears, Roebuck catalogue from about 1903.

14 "Japonisme dans la mode étant une des originalités du moment," *Les Modes*, March 1907, 12.

15 A succession of Japanese-themed dramas and operas was staged in the late nineteenth and early twentieth centuries. *The Mikado* attracted attention in London in 1885, and in 1907 Judith Gautier's *Princesses d'amour*, Puccini's *Madama Butterfly*, and the appearance of Japanese actress Hanako in a Parisian theater all aroused interest.

16 "A large rectangular kimono made of black wool, hemmed in black satin. The embroidery on the wide sleeves resembled those of a Chinese coat." Paul Poiret, *En habillant l'époque* (1930; Paris: Grasset, 1978), 49.

17 Until the mid-1920s no curves whatsoever appeared in Vionnet's designs. An example of her typical linear approach is a 1922 wedding dress in the Kyoto Costume Institute collection (AC7007 91-15-3A).

18 Akiko Fukai, *The Kimono and Japonism* (Tokyo: Heibonsha, 2017), 266–76.

19 Betty Kirke, *Madeleine Vionnet* (Tokyo: Kyuryudo; San Francisco: Chronicle, 1991), 46 and 77.

Wearing Japonism

The Cincinnati Art Museum would like to thank Director of Collections and Exhibitions Susan Hudson, Kim Flora and the Design and Installation team, Textile Conservator Obie Linn, and Curatorial Assistant Adam MacPharlain for their contributions to the publication and exhibition.

1 Margaret Breukink-Peeze, "Japanese Robes: A Craze," in *Imitation and Inspiration: Japanese Influence on Dutch Art*, ed. Stefan Van Raay (Amsterdam: Art Unlimited, 1989), 54–55. See, for example: *Portrait of a Man*, about 1676, attributed to Caspar Netscher, Museo Nacional Thyssen Bornemisza, Madrid, inv. no. 301 (1930.79). An eighteenth-century man's morning gown (*Japonsche rock*) in the collection of the Centraal Museum, Utrecht, is illustrated in Amelia Peck, ed., *Interwoven Globe: The Worldwide Textile Trade, 1500–1800* (New Haven, CT: Yale University Press, 2013), 262, as is a man's morning gown (*banyan*) from England from the same period in the collection of the Metropolitan Museum of Art (265).

2 Toshio Watanabe, *High Victorian Japonisme* (Bern: Peter Lang, 1991), 94–98.

3 Ayako Ono, *Japonisme in Britain: Whistler, Menpes, Henry, Hornel, and Nineteenth-Century Japan* (London: RoutledgeCurzon, 2003), 59.

4 *The International Exhibition of 1862: The Illustrated catalogue of the industrial department, British Division*, vol. 1 (London: 1862), 119–20.

5 Watanabe, *High Victorian Japonisme*, 92.

6 Moyra Clare Pollard, *Master Potter of Meiji Japan: Makuzu Kōzan (1842–1916) and His Workshop* (New York: Oxford University Press, 2002), 21.

7 Tamami Suoh, "Exported Dressing Gowns of the Meiji Period," in *The Elegant Other: Cross-cultural Encounters in Fashion and Art* (Japan: Rikuyōsha, 2017), 187–88; Otto Charles Thieme, *With Grace and Favour: Victorian and Edwardian Fashion in America* (Cincinnati: Cincinnati Art Museum, 1993), 49, 51.

8 Joseph McLaughlin, "'The Japanese Village' and the Metropolitan Construction of Modernity," *Romanticism and Victorianism on the Net* 48 (November 2007); Ella Sterling Cummins, *A Veritable Japanese Village: Under the Sanction of the Imperial Japanese Government; a colony of Japanese men, women and children in native costume who daily illustrate the art industries of Japan* (Boston: 1886).

9 Terry Satsuki Milhaupt, *Kimono: A Modern History* (London: Reaktion, 2014), 141, 143.

10 Jan Walsh Hokenson, *Japan, France, and East-West Aesthetics: French Literature, 1867–2000* (Madison, NJ: Fairleigh Dickinson University Press, 2004), 185–86.

11 Tissot's *La Japonaise au bain* is in the collection of Musée des Beaux-Arts de Dijon; Renoir's *Madame Hériot* is in the collection of Hamburger Kunsthalle, Hamburg.

12 For a full discussion of reform dress, see Patricia Cunningham, *Reforming Women's Fashion, 1850–1920: Politics, Health, and Art* (Kent, OH: Kent State University Press, 2003). For a full discussion of the tea gown, see Anne Bissonnette, "The 1870s Transformation of the Robe de Chambre," in *A Separate Sphere: Dressmakers in Cincinnati's Golden Age, 1877–1922*, by Cynthia Amnéus (Lubbock: Texas Tech University Press, 2003).

13 For a general discussion of Liberty's dress and textile designs, see Barbara Morris, *Liberty Design, 1874–1914* (Secaucus, NJ: Chartwell, 1989), 42–59.

14 Advertisement for A. A. Vantine & Co., *Harper's Bazaar* 26, no. 45 (November 11, 1893): 934.

15 "The Kimono and How to Make It," *Maine Farmer and Journal of the Useful Arts* 65, no. 9 (December 31, 1896): 3.

16 Article, *Harper's Bazaar* 32, no. 43 (October 28, 1899): 917; "Full-Length Kimono," *Harper's Bazaar* 32, no. 43 (October 28, 1899): 909; May Manion, "Home Dressmaking," *Massachusetts Ploughman and New England Journal of Agriculture* 62, no. 2 (October 5, 1901): 7.

17 "Woman's Kimono," *Harper's Bazaar* 32, no. 2 (June 1901): 168; "Our Patterns," *Ohio Farmer* 101, no. 5 (January 30, 1902): 106; "House Gowns and Negligees," *Harper's Bazaar* 38, no. 10 (October 1904): 946.

18 Page's kimono was later donated to the Cincinnati Art Museum by her great-granddaughter.

19 For a full discussion of the construction of early-twentieth-century kimonos and dressing gowns in the collection of the Kyoto Costume Institute, see Suoh, "Exported Dressing Gowns," 188–89.

20 *Vogue* 36, no. 9 (November 1, 1910): 8.

21 See, for instance, silk kimono listed in Alms & Doepke ads in the *Cincinnati Enquirer*, October 6, 1912; November 10, 1912; and July 5, 1914.

22 Kristin Hoganson, "Cosmopolitan Domesticity: Importing the American Dream, 1865–1920," *American Historical Review* 107, no. 1 (February 2002): 55–83.

23 Cate Family Papers (1864–1978) are in the collection of the Vermont History Center, Barre, VT.

Occidentalisms in Japanese Fashion

The Newark Museum wishes to acknowledge the work of Dr. Laura Mueller, Casey Daurio, Amber Germano, Andrea Ko, Millicent Matthews, Mary Dowd, Seth Goodwin, David Bonner, and Jason Wyatt for their contributions to the success of the publication and exhibition.

1 This is visually apparent in the dress of not only the historical Buddha Shakyamuni but also monks and Buddhist deities—particularly the Shitennō, or four heavenly kings. The collection of the Newark Museum, Newark, NJ, contains many examples demonstrating this iteration of Occidentalism, including objects 9.932, 9.937, 26.135, 31.1026, 41.340, 41.1456, 65.73, 67, 107, 68.14, 94.183, and 98.21, among others, available at www.newarkmuseum.org/search-our-collection.

2 William B. Hauser, *Economic Institutional Change in Tokugawa Japan: Osaka and the Kinai Cotton Trade* (Cambridge: Cambridge University Press, 2010).

3 One outstanding example in the Seattle Art Museum (63.151) is a portrait currently identified as Amakusa Shirō Tokisada (1620–1638), leader of the Christian Shimabara Rebellion, who wears an Occidentalist outfit featuring a neck ruff and holding a Christian cross and flintlock musket (search for image at http://art.seattleartmuseum.org/advancedsearch). The painting is published in black and white in Mattiebelle Gittinger, *Master Dyers*

to the World: Technique and Trade in Early Indian Dyed Cotton Textiles (Washington, DC: George Washington University, the Textile Museum, 1982), 167.

4 Two examples of early Occidentalist robes are the imported embroidered velvet mantle worn by Toyotomi Hideyoshi in the Nagoya City Hideyoshi and Kiyomasa Memorial Museum, Aichi collection, and a military robe in the Fukuoka Art Museum; see Kyushu National Museum, *Daikōkai jidai no nihon bijutsu: tokubetsuten shin Momoyama ten* (Fukuoka: Nishinihon Shinbunsha, 2017),104, for images of these textiles, and 138–47, for surviving paintings of Occidental fashions.

5 Gakusho Nakajima provides an outstanding overview of the dynamics of international trade (both legally sanctioned and illicit) in Japan from 1534 to 1616. For an English translation of his article, see Gakusho Nakajima, "Nobunaga, Hideyoshi and Ieyasu in the Age of Exploration," in Kyushu National Museum, *Daikōkai jidai*, vi x.

0 This purposeful pairing connects the luxury imports of textiles and tobacco. Tobacco first was imported by the Portuguese in the sixteenth century, before it was domestically produced in Japan. See the collection of the Tobacco and Salt Museum, Tokyo, for outstanding examples of *sarasa* fabrics as tobacco pouches. See also Sachio Yoshioka, *Sarasa, Printed and Painted Textiles*, vol. 20 of Kyoto Shoin's Art Library of Japanese Textiles (Kyoto: Kyōto Shoin, 1993), 58–77. For a longer overview of South Asian textiles in Japan—including surviving Japanese pattern books that feature South Asian motifs (such as *Sarasa benran*, published in 1781)—see Gittinger, *Master Dyers*,

167–73; and object E.6924-1916 in the collection of the Victoria and Albert Museum, London, http://collections.vam.ac.uk/item/O488694/sarasa-benran-book-chika-ari-kasumi/.

7 See Terry Satsuki Milhaupt, *Kimono: A Modern History* (London: Reaktion, 2014), 43–44; and Amelia Peck and Amy Elizabeth Bogansky, *Interwoven Globe: The Worldwide Textile Trade, 1500–1800* (New York: Metropolitan Museum of Art, 2013), 177–80.

8 This communication with South and Southeast Asia was not unilateral. Surviving Japanese commissions of printed and resist-dyed cottons from textile producers in these regions feature not only images of Dutchmen but also images of the Gion Festival; see Yoshioka, *Sarasa*, 80–81.

9 One Dutchman is even rendered in a state of donning or removing his wrapped trousers; see the following objects in the collection of the Newark Museum: Gift of Herman A. E. Jaehne and Paul C. Jaehne, 1938: 38.681/4154.31; 38.681/4161.31; 38.681/4990.31; 38.681/4995.31; 38.681/5192.31; 38.681/5378.31; 38.681/5349.31 (for Dutchmen); 38.681/4161.31; 4171.31; 38.681/4161.31; 5342.31 (for Chinamen). See also Barbra Teri Okada and Valrae Reynolds, *Japan, the Enduring Heritage: Selections from the Newark Museum Collection*, special issue, *Newark Museum Quarterly* 32, nos. 2–3 (1983): 8 and 61.

10 Between 1914 and 1917 Japan became one of the largest exporters of cotton and silk goods to the West, capturing 70 percent of the US market at one point; see Milhaupt, *Kimono*, 67–69. As was the case in early Western industrialization, large numbers of women were employed in these textile mills.

11 Men were required to adopt Western dress at court in 1872; women, in 1876. For an in-depth treatment of this subject, see Ken'ichirō Hirano, "The Westernization of Clothes and the State in Meiji Japan," in *The State and Cultural Transformation: Perspectives from East Asia* (Tokyo: United Nations University Press, 1993), 121–31.

12 Just as the West embraced Japanese irises and chrysanthemums for Western gardens and as ornament on garments—as in the Jacques Doucet day dress (cat. 8) and the Chanel evening coat (cat. 16) featured in this catalogue—exotic Western flowers (such as tulips, in 1911) were transported to Japan and featured as Occidentalist motifs on Japanese kimono.

13 Similar items made at a slightly later date were available through mail-order catalogues such as Liberty & Co. of London; see Jun I. Kindai, Akiko Fukai, Shūji Takashina, and Jun I. Kanai, *Mōdo no japonisumu* (Kyoto: Kyōto Fukushoku Bunka Kenkyū Zaidan, 1996), 71.

14 The building, designed by Josiah Condor (1852–1920), employed an inventive pastiche of Western styles. The decorative arts of the interior included Western-style flatware, ceramics, tables, and chairs, and the menu featured French cuisine. For overviews of the Rokumeikan era in relation to the rise and fall in popularity of *yōfuku*, see Milhaupt, *Kimono*, 56–62; and John E. Vollmer, *Re-envisioning Japan: Meiji Fine Art Textiles* (Milan: Five Continents Editions, 2016), 56–71.

15 Numerous prints made for a Japanese audience by Utagawa Hiroshige III (1843–1894), Utagawa Yoshiku (1833–1904), Yōshū (Hashimoto) Chikanobu (1838–1912),

Adachi Ginkō (Shōsai) (1873–1908), Inoue Yasuji (1864–1889), and Utagawa Kokunimasa (1874–1944) depict iterations of *yōfuku* worn by fashionable Japanese. These provide a fascinating complement to *yokohama-e* prints that render images of Westerners in Japan in the same period. See Ann Yonemura, *Yokohama: Prints from Nineteenth-Century Japan* (Washington, DC: Arthur M. Sackler Gallery, 1990).

16 The production of clothing exclusively for noninfant children's wear became a global phenomenon starting in the late nineteenth century.

17 *Yōfuku* was emphasized for children's and men's wardrobes in Sugiura Hisui, *Shin-an katei ishō awase* [New game of fashion for the family], supplement to *Mitsukoshi Times* 8, no. 1 (January 1910); reprinted in Milhaupt, *Kimono*, 107. For more on the rise of Japanese department stores, see Milhaupt, *Kimono*, 113–26.

18 The primary thesis of Terry Milhaupt's publication is the exploration of the continued relevancy of kimono even as Japan embraced Western dress; see Milhaupt, *Kimono*.

19 For two views of Japanese immigration, see Peter Duus, *The Japanese Discovery of America: A Brief History with Documents* (Boston: Bedford Books, 1997); and James C. Baxter, Shūhei Hosokawa, and Junko Ota, *Cultural Exchange between Brazil and Japan: Immigration, History, and Language Nihon Burajiru bunka kōryū: Gengo, rekishi, imin* (Kyoto: International Research Center for Japanese Studies, 2009).

20 The Newark Museum's kimono with butterfly and floral motifs (29.3A,B; see p. 15, fig. 3) showcases this fashion for shorter styles while displaying bright synthetic dyes and machined silks of the period. For illustrations

of chic Japanese shoppers wearing overcoats with the cocoon cut of the Linker evening coat (cat. 14), see Sawabata Ryūshi, *Kaimono sugoroku: ichimei depaatomento sutoa* [Shopping Sugoroku: department store], supplement to *Shōjo no tomo* [Young girls' companion] (Tokyo), January 1914; see also Milhaupt, *Kimono*, 228.

21 See Ai Maeda, "The Development of Popular Fiction in the Late Taishō Era: Increasing Readership of Women's Magazines," in *Text and the City: Essays on Japanese Modernity*, ed. James A. Fujii, trans. Rebecca Copeland (Durham, NC, and London: Duke University Press, 2004), 163–219.

22 For a comprehensive treatment of the international expanse of Art Deco, see Charlotte Benton, *Art Deco: 1910–1939* (London: V&A Publishing, 2015). For a narrower look at Art Deco in Japan, see Kendall H. Brown, *Deco Japan: Shaping Art and Culture, 1920–1945* (Alexandria, VA: Art Services International, 2012).

Deconstruction and Refashioning Japonism

The Asian Art Museum of San Francisco gratefully acknowledges the numerous staff members whose creativity and hard work have made this exhibition and publication possible. Special thanks go to Peter Cargile, Marco Centin, Caren Gutierrez, Tim Hallman, Maya Hara, Clare Jacobson, Ruth Keffer, Cathy Mano, Denise Migdail, Kate Ritchey, and Stephanie Reeves.

1 Melissa Marra-Alvarez, "When the West Wore East: Rei Kawakubo, Yohji Yamamoto, and the Rise of the Japanese Avant-Garde in Fashion," *DRESSTUDY* 57 (Spring 2010): 1–2, www.kci.or.jp/research/dresstudy/pdf/D57_Marra_Alvarez_e_When_the_West_Wore_East.pdf.

2 Rei Kawakubo, quoted in Bernadine Morris, "From Japan, New Faces, New Shapes," *New York Times*, December 14, 1982, cited in Marra-Alvarez, "When the West Wore East," 3.

3 Marra-Alvarez, "When the West Wore East," 1.

4 Jacques Derrida, on the occasion of the International Symposium on Deconstruction, London, 1988, cited in Andreas C. Papadakis, ed., *Deconstruction II* (London: Architecture Design, 1999), 7.

5 Derrida's correspondent was Toshihiko Izutsu, a professor of comparative religions who was fluent in more than thirty languages. Izutsu had spent considerable time on the comparative ethics and philosophies of Islam and Zen Buddhism and had authored the first direct translation of the Qu'ran from Arabic into Japanese in 1958. This is to say, Izutsu was familiar with the hazards and rewards of translation, both linguistic and cultural, and was someone who would value Derrida's words on what deconstruction was and was not.

6 Jacques Derrida, "Letter to a Japanese Friend," in *Derrida and Difference*, eds. Robert Bernasconi and David Wood (Warwick, UK: Parousia Press, 1985), 71–82.

Japonism in Art and Fashion

1 Goods from Japan, such as lacquers and porcelains, had been exported to the West in the sixteenth century and even during the period of self-seclusion from the 1630s to the 1850s. The opening of Japan to trade led to a much greater flow of Japanese goods into the West.

2 The nineteenth-century understanding of Japonism as "a craze for Japanese art and culture" has today shifted to "the Japanese influence on Western art." Art critic Philippe

Burty (1830–1890) used the French term *Japonisme* for the first time in "Japonisme," *La Renaissance littéraire et artistique*, May 1872, 25.

3 Van Gogh also painted *Flowering Plum Orchard* (1887) and *Bridge in the Rain* (1887), copies of the prints *Plum Estate, Kameido* (1857) and *Sudden Shower over Shin-Ōhashi Bridge and Atake* (1857) by Utagawa Hiroshige (1797–1858).

4 Ernest Chesneau, "Le Japon à Paris," *Gazette des beaux-arts*, September 1878, 387.

5 Louis Gonse, "L'art japonais et son influence sur le gout européen," *Revue des arts décoratifs*, April 1898, 112.

6 Richard Muther, *The History of Modern Paintings* (London: Dent; New York: Dutton, 1907), 104.

7 Vincent van Gogh to Theo van Gogh, July 15, 1888, letter 640, http://vangoghletters.org/vg/letters/let640/letter.html.

8 Richard J. Boyle, "Arthur Wesley Dow in Japan," *Archives of American Art Journal* 52, nos. 1–2 (2013 Spring), 60.

9 Roger Marx, "'Les Nymphéas' de M. Claude Monet," *Gazette des beaux-arts*, June 1909, 528.

10 Designers such as Poiret and Vionnet moved away from the corset. In addition to kimono, the cylinder form can be attributed to ancient Greek garments: the chiton, peplos, and himation. Although the source of inspiration for these styles cannot be precisely and positively identified, it is apparent that their flat construction draws on traditions outside nineteenth-century Western fashion.

11 Japanese textile artisans developed a wide range of luxurious fabrics to embellish kimono, in part possibly because of its simple structure.

12 MIYAKE DESIGN STUDIO website, http://mds.isseymiyake.com/mds/en/collection/.

13 Siegfried Bing, introduction, *Le Japon artistique* 1 (May 1888): 5.

Why an Exhibition on Kimono Refashioned?

1 Andrew Bolton, preface to *Alexander McQueen: Savage Beauty*, by Andrew Bolton, Alexander McQueen, Susannah Frankel, Tim Blanks, and Sølve Sundsbø (New York: Metropolitan Museum of Art, 2011), 13.

2 For more on "Cool Japan" and Tokyo street fashion, see Anne Garrigue, "Comme un Nippon, j'ai les cheveux roses. . .," *Elle*, October 4, 1999, 151–54; Bethan Cole, "Looks: Teen Rebels," *American Vogue* 166 (September 2000): 123–24; and Marion Hune, "Tokyo Glamorama," *Harper's Bazaar*, October 2000, 312–15, 338.

3 Nobuhiko Maruyama, *Edo mōdo no tanjō: Mon'yō no ryūkō to sutā eshi* (Tokyo: Kadokawa Gakugei Shuppan, 2008), 116.

Kimono in Contemporary Fashion

1 See http://mds.isseymiyake.com/mds/en/collection/.

2 "Star Turn," *Vogue* (US), September 1991, 147.

3 Yoshida Kenkō, *Essays in Idleness*, trans. Donald Keene (Tokyo: Tuttle, 2006).

Japan Pop

1 Osamu Tezuka, *Asu o kirihiraku Tezuka Osamu no kotoba nihyakuichi: Ima o ikiru hitotachi e* (Tokyo: Pia, 2005), 153.

2 "Nozomi Ishiguro Haute Couture," *Fashion News* 193 (January 2015): 83.

aizome Indigo dyeing. A dye technique whereby cloth or thread is immersed in a vat of indigo dye. Repeated dipping produces ever-darker blues.

bias cut Cutting textiles at a 45-degree angle to the warp and weft, or diagonally across the grain. This type of cut gives cloth elasticity.

boro Old, worn cloth; also: worn-out, ragged, or darned and patched clothing.

broadcloth A North American term for a very finely woven fabric, usually plain-weave cotton. Originally broadcloth referred to woven fabrics that were wider than twenty-seven inches.

broché Brocaded fabric. Gorgeously patterned fabric in which supplementary pattern wefts work back and forth in each color area; also the technique of creating this fabric. Because the pattern stands out in relief, broché tends to be used for main motifs when combined with other patterning techniques. It appears frequently on eighteenth-century women's robes.

bustle style A style of women's clothing fashionable in the 1870s and 1880s in which an understructure known as a bustle holds up the back of the skirt so it bulges over the buttocks.

chirimen Silk crepe. Plain-weave silk cloth woven with untwisted raw-silk warp threads and tightly twisted raw-silk weft thread, which produce its characteristic finely puckered surface.

crinoline A petticoat designed to fill out a skirt, first used in the 1840s. The name is derived from the practice of incorporating stiff wefts made of horsehair ("crino") into a linen cloth ("lin"). Skirts composed of multiple horizontal hoops appeared around 1856, inheriting the name "crinoline" when patented. Skirts were at their widest in the mid-1860s.

damask A self-patterned (single warp and single weft) fabric combining two different weave structures to create the pattern and ground. The design and background color reverse on the front and back, producing a reversible cloth.

date-eri A collar—worn between an inner collar (*han-eri*) and a kimono—designed to look like an extra layer of clothing.

dolman sleeve A loose sleeve cut in one piece with the body of a garment, generally with a low armhole.

dotera A wide-sleeved padded kimono worn to ward off cold weather. It has cotton wadding inserted between the face fabric and the lining; also known as a *tanzen* (quilted dressing gown).

fuki A padded hem or cuff on a kimono. It gives a full, soft impression.

fundō tsunagi A pattern created by interlinking the shapes of traditional Japanese counterweights; thought to bring good luck.

Genji guruma An abstract design based on the wheel of an oxcart used to transport nobles.

goshodoki Designs featuring houses, fences, fans, aristocratic oxcarts, and the like set within a landscape or among plant imagery. The exact content varies considerably but is characterized by items referencing classical literature or Noh plays. It was especially popular as a kimono pattern for elite military-class ladies of the mid-eighteenth to mid-nineteenth century.

han-eri A decorative collar sewn onto a *juban*.

haori A short garment worn over a kimono. Its lining frequently bears a design.

Ichimai no nuno "A Piece of Cloth (A-POC)." The concept of clothing that Issey Miyake exhibited at Seibu Museum of Art, Tokyo, in 1977. These modern garments employ methods of kimono construction based on straight seams and the use of flat pieces of cloth. *Ichimai no nuno* formed the foundation for all Miyake's subsequent work.

itajime shibori Clamp-resist dyeing, in which folded cloth is clamped between boards that may have been carved with matching relief patterns. Dye penetrates only those areas not tightly bound between the clamped boards. See also **shibori.**

Japonsche rocken Men's dressing gowns, popular in Holland in the seventeenth and eighteenth centuries, that were originally derived from the Japanese padded night kimono. The Dutch called similar garments made in India or other places *Japonsche rocken* as well. Called *banyans* in English and *indiennes* in French.

juban A garment worn under a kimono.

kakuwachigai A pattern of linked intersecting circles and squares.

kasumi A pattern based on the shape of trailing mist.

katazome A method of dyeing in which the dye or resist paste is printed on the fabric using a carved wooden stamp or a paper stencil.

kimono A traditional Japanese garment. Kimono is an abbreviation of *kirumono* (literally "thing to wear"). The present-day kimono is based on the *kosode*, which has a long history. See also **kimono-style dressing gown** and **kosode.**

kimono sleeve A sleeve that is attached to the garment body at a ninety degree angle and extends horizontally. It has no contoured armhole.

kimono-style dressing gown In the early twentieth century, the term *kimono* was borrowed to describe a new type of dressing gown that appeared in Europe and America. See **kimono.**

kosode "Small sleeve." The term used in the Edo period for the garment that became the model for the kimono as it is known today. The *kosode* referred to in this exhibition are principally garments popular with warrior- and merchant-class ladies during the second half of the nineteenth century. See **kimono.**

lancé A multicolored patterned weave in which the continuous-pattern wefts travel from selvage to selvage and appear on the face of the fabric only in the pattern area; also fabrics made using this technique. As the motifs do not stand out in relief, lancé is often used to weave background patterns.

liseré A patterned weave in which the same wefts are used to weave the foundation and the design; also fabrics made with this technique. The term comes from the French word for "border" and was often used in the late eighteenth century for stripe patterns in ladies' robes.

mitate A contemporary reworking of a classical literary theme, often translated as "parody."

Miura shibori A variant of tie-dye dots in which a thread is looped once around each small pinch of cloth in continuous rows. See also **shibori.**

nashiji-ori "Pear-skin" weave. Named after a lacquer technique known as *nashiji*, textiles with fine surface bumps created by the warps and wefts crossing at irregular intervals and thus producing uneven warp and weft floats. It lacks luster, and the coarse texture somewhat resembles the skin of a pear or sand.

Nishijin-ori A general term for yarn-dyed woven textiles produced in the Nishijin area of Kyoto. Famous as luxurious, opulent, high-quality figured cloth employing a lot of gold thread, these fabrics are often used for obi.

ohikizuri A long-trailing kimono hem.

okezome "Tub-resist dyeing." A method of dyeing parts of a cloth with different colors. Areas of the fabric to remain undyed are stuffed into a tub, which is sealed tightly when the cloth is immersed in a vat of dye.

132 5. ISSEY MIYAKE A brand begun in 2010 by ISSEY MIYAKE and designed by Issey Miyake and Reality Lab. It developed complex three-dimensional structures created by folding cloth, inserting cutting lines, and pressing.

organza A lightweight, transparent, stiff textile woven with long filament threads in plain weave.

rinzu Satin cloth with a woven pattern produced by reversing the warp-face (long warp floats) in relation to its corresponding weft-faced structure (long weft floats). The fabric is smooth and glossy and has body.

ro A thin fabric woven with a combination of leno (open) and plain weave. A summer fabric characterized by gaps in the weave where the warps cross and uncross for the leno.

sashiko Quilted layers of cotton cloth sewn with straight stitch. This strengthens the cloth and increases its warmth.

shibori A generic term for various types of bind-resist dyeing, including tie-dyeing and clamp-resist dyeing. The technique is used throughout the world. A large variety of *shibori* techniques are found in Japan, ranging from specialized local techniques with names that include their place of production to those produced all across the country. Examples include **te-kumo shibori** (spiderweb), **Miura shibori** (single-wrap dots), and **itajime shibori** (clamp resist).

shihō mokkō A pattern based on the cross-section of a gourd; also used as a family crest.

Super Organza (Ten'nyo no hagoromo) An organza woven with monofilament polyester measuring five to seven denier and developed by the Japanese firm Amaike Textile Industry Co. Ltd. The Japanese name relates to a folk legend called "The Feather Mantle" (*Hagoromo*).

te-kumo shibori Spiderweb *shibori*, among the oldest of the many dyeing techniques from Arimatsu in Aichi prefecture, gets its name from the spiderweb pattern it produces, achieved by first pleating then binding the fabric. See also **shibori.**

3D Steam Stretch A method of producing pleats developed by ISSEY MIYAKE in 2014: a precise composition of cotton and polyester threads are woven into fabric that is then treated with heat and steam, resulting in shrinkage that creates the garment form.

uchikake A type of kimono worn by upper-class ladies in the Edo period (1615–1868). Shaped like the *kosode*, it was worn unbelted over the *kosode*. Today *uchikake* are worn as bridal robes.

visite A loose cape-like outer garment worn over a bustle-style dress popular during the 1870s and 1880s. See also **bustle style.**

yūzen A dyeing technique developed around the end of the seventeenth century that uses a combination of resist-paste dyeing and hand painting on color to create an ornate, multicolored pattern.

Ambrose, Gavin, and Paul Harris. *The Visual Dictionary of Fashion Design*. Lausanne: AVA, 2007.

Amnéus, Cynthia. *Wedded Perfection: Two Centuries of Wedding Gowns*. London: D. Giles, 2010.

Baxter, James C., Shūhei Hosokawa, and Junko Ota. *Cultural Exchange between Brazil and Japan: Immigration, History, and Language / Nihon Burajiru Bunka Kōryū: Gengo, Rekishi, Imin*. Kyoto: International Research Center for Japanese Studies, 2009.

Benton, Charlotte, Tim Benton, and Ghislaine Wood. *Art Deco: 1910–1939*. London: V&A Publishing, 2015.

Bing, Siegfried. Introduction. *Le Japon artistique* 1 (May 1888): 1–10.

Bissonnette, Anne. "The 1870s Transformation of the Robe de Chambre." In *A Separate Sphere: Dressmakers in Cincinnati's Golden Age, 1877–1922*, by Cynthia Amnéus, 169–73. Lubbock: Texas Tech University Press, 2003.

Bloomingdale Brothers and Henry Ford Museum and Greenfield Village. *Bloomingdale's Illustrated 1886 Catalog: Fashions, Dry Goods, and Housewares*. New York: Dover, 1988.

Bolton, Andrew, Alexander McQueen, Susannah Frankel, Tim Blanks, and Sølve Sundsbø. *Alexander McQueen: Savage Beauty*. New York: Metropolitan Museum of Art, 2011.

Boyle, Richard J. "Arthur Wesley Dow in Japan." *Archives of American Art Journal* 52, nos. 1–2 (Spring 2013): 58–69.

Breukink-Peeze, Margaret. "Japanese Robes: A Craze." In *Imitation and Inspiration: Japanese Influence on Dutch Art*, edited by Stefan Van Raay, 54–59. Amsterdam: Art Unlimited, 1989.

Brown, Kendall H. *Deco Japan: Shaping Art and Culture, 1920–1945*. Alexandria, VA: Art Services International, 2012.

Brown, Kendall H., and Sharon Minichiello. *Taisho Chic: Japanese Modernity, Nostalgia, and Deco*. Seattle: University of Washington Press, 2005.

Burty, Philippe. "Japonisme." *La Renaissance littéraire et artistique*, May 1872, 25–26.

Cate Family Papers, 1864–1978. Leahy Library, Vermont History Center, Barre, VT.

Champfleury (Jules François Felix Fleury-Husson). "La mode des Japonaiseries." *La Vie Parisienne*, November 21, 1886, 862–63.

Chesneau, Ernest. "Le Japon à Paris." *Gazette des beaux-arts*, September 1878, 385–97.

———. "Le Japon et l'art japonais." *Journal des Demoiselles*, November 1868, 322.

Clark, John, and Elise K. Tipton. *Being Modern in Japan: Culture and Society from the 1910s to the 1930s*. Honolulu: Univ. of Hawai'i Press, 2000.

Cole, Bethan. "Looks: Teen Rebels." *American Vogue* 166, September 2000, 123–24.

Crisci-Richardson, Roberta. *Mapping Degas: Real Spaces, Symbolic Spaces, and Invented Spaces in the Life and Work of Edgar Degas (1834–1917)*. Newcastle upon Tyne: Cambridge Scholars, 2015.

Cummins, Ella Sterling. *A Veritable Japanese Village: Under the Sanction of the Imperial Japanese Government; a colony of Japanese men, women and children in native costume who daily illustrate the art industries of Japan*. Boston: 1886.

Cunningham, Patricia. *Reforming Women's Fashion, 1850–1920: Politics, Health, and Art*. Kent, OH: Kent State University Press, 2003.

Dalby, Liza Crihfield. *Kimono: Fashioning Culture*. Seattle: University of Washington Press, 1993.

Derrida, Jacques. "Letter to a Japanese Friend." In *Derrida and Difference*, ed. Robert Bernasconi and David Wood. Warwick, UK: Parousia Press, 1985.

———. *Of Grammatology*. Translated by Gayatri Chakravorty Spivak. With an introduction by Judith P. Butler. Baltimore: Johns Hopkins University Press, 2016.

Duus, Peter. *The Japanese Discovery of America: A Brief History with Documents*. Boston: Bedford Books, 1997.

English, Bonnie. *Japanese Fashion Designers: The Work and Influence of Issey Miyake, Yohji Yamamoto, and Rei Kawakubo*. London: Bloomsbury Academic, 2015.

Fukai, Akiko. *The Kimono and Japonism*. Tokyo: Heibonsha, 2017.

"Full-Length Kimono." *Harper's Bazaar* 32, no. 43 (October 28, 1899): 909.

Garrigue, Anne. "Comme un Nippon, j'ai les cheveux roses" *Elle*, October 4, 1999, 151–54.

Geczy, Adam, and Vicki Karaminas. *Critical Fashion Practice: From Westwood to Van Beirendonck*. London: Bloomsbury Academic, 2017.

Genova, Pamela Antonia. *Writing Japonisme: Aesthetic Translation in Nineteenth-Century French Prose*. Evanston, IL: Northwestern University Press, 2016.

Gittinger, Mattiebelle. *Master Dyers to the World: Technique and Trade in Early Indian Dyed Cotton Textiles*. Washington, DC: George Washington University, The Textile Museum, 1982.

Goncourt, Edmond de. *La maison d'un artiste*. 2 vols. Paris: Charpentier, 1881.

Goncourt, Edmond de, and Jules de Goncourt. 3 vols. *Journal: Mémoires de la vie littéraire*. Paris: Laffont, 1989.

Gonse, Louis. "L'art japonais et son influence sur le gout européen." *Revue des arts décoratifs*, April 1898, 97–116.

Hauser, William B. *Economic Institutional Change in Tokugawa Japan: Osaka and the Kinai Cotton Trade*. Cambridge: Cambridge University Press, 2010.

Heidegger, Martin, and Joan Stambaugh. *Being and Time: A Translation of* Sein und Zeit. Chicago: University of Chicago, 1996.

Hirano, Ken'ichirō. *The State and Cultural Transformation: Perspectives from East Asia*. Tokyo: United Nations University Press, 1993.

Hoganson, Kristin. "Cosmopolitan Domesticity: Importing the American Dream, 1865–1920." *American Historical Review* 107, no. 1 (February 2002): 55–83.

Hokenson, Jan Walsh. *Japan, France, and East-West Aesthetics: French Literature, 1867–2000*. Madison, NJ: Fairleigh Dickinson University Press, 2004.

"House Gowns and Negligees." *Harper's Bazaar* 38, no. 10 (October 1904): 946.

Hune, Marion. "Tokyo Glamorama." *Harper's Bazaar*, October 2000, 312–15, 338.

Hunter, Janet. *The Emergence of Modern Japan: An Introductory History since 1853*. London and New York: Longman, 1989.

The International Exhibition of 1862: The Illustrated Catalogue of the Industrial Department, British Division, vol. 1. London: 1862.

Kawamura, Yuniya. *The Japanese Revolution in Paris Fashion*. Oxford and New York: Berg, 2006.

"The Kimono and How to Make It." *Maine Farmer and Journal of the Useful Arts* 65, no. 9 (December 31, 1896): 3.

Kirke, Betty. *Madeleine Vionnet*. Tokyo: Kyuryudo, 1991; San Francisco: Chronicle, 1998.

Kramer, Elizabeth. "Master or Market? The Anglo-Japanese Textile Designs of Christopher Dresser." *Journal of Design History* 19, no. 3 (Autumn 2006): 197–214.

Kyōto Kokuritsu Kindai Bijutsukan and Kyōto Fukushoku Bunka Kenkyū Zaidan. *Japonism in Fashion*. Kyoto: Kyoto Costume Institute, 1994.

Kyushu National Museum. *Daikōkai jidai no nihon bijutsu: tokubetsuten shin momoyamaten*. Fukuoka: Nishinihonshinbunsha, 2017.

Lambourne, Lionel. *Japonisme: Cultural Crossing between Japan and the West*. London: Phaidon, 2007.

Loscialpo, Flavia. "Fashion and Philosophical Deconstruction: A Fashion In-Deconstruction." In *Fashion Forward*, by Alissa De Witt-Paul and Mira Crouch, 13–27. Oxford: Inter-disciplinary Press, 2011. E-book. http://public.eblib.com/choice/publicfullrecord.aspx?p=3316256.

Maeda, Ai. *Text and the City: Essays on Japanese Modernity*. Edited by James A. Fujii. Translated by Rebecca Copeland. Durham, NC, and London: Duke University Press, 2004.

Manion, May. "Home Dressmaking." *Massachusetts Ploughman and New England Journal of Agriculture* 62, no. 2 (October 5, 1901): 7.

Marra-Alvarez, Melissa. "When the West Wore East: Rei Kawakubo, Yohji Yamamoto, and the Rise of the Japanese Avant-Garde in Fashion."

DRESSTUDY 57 (Spring 2010). www.kci.or.jp/research/dresstudy/pdf/D57_Marra_Alvarez_e_When_the_West_Wore_East.pdf.

Marshall, Nancy Rose, and Malcolm Warner. *James Tissot: Victorian Life/Modern Love*. New Haven: Yale University Press, 1999.

Maruyama, Nobuhiko. *Edo mōdo no tanjō: Mon'yō no ryūkō to sutā eshi*. Tokyo: Kadokawa Gakugei Shuppan, 2008.

Marx, Roger. "'Les Nymphéas' de M. Claude Monet." *Gazette des beaux-arts*, June 1909, 523–31.

McLaughlin, Joseph. "'The Japanese Village' and the Metropolitan Construction of Modernity." *Romanticism and Victorianism on the Net* 48 (November 2007).

McNeil, Peter, and Sanda Miller. *Fashion Writing and Criticism: History, Theory, Practice*. London: Bloomsbury Academic, 2014.

Milhaupt, Terry Satsuki. *Kimono: A Modern History*. London: Reaktion, 2014.

Morris, Barbara. *Liberty Design, 1874–1914*. Secaucus, NJ: Chartwell, 1989.

Muther, Richard. *The History of Modern Paintings*. London: Dent; New York: Dutton, 1907.

Okada, Barbra Teri, and Valrae Reynolds. *Japan, the Enduring Heritage: Selections from the Newark Museum Collection*. Special issue, *Newark Museum Quarterly* 32, nos. 2–3 (1983).

Ono, Ayako. *Japonisme in Britain: Whistler, Menpes, Henry, Hornel, and Nineteenth-Century Japan*. London: RoutledgeCurzon, 2003.

"Our Patterns." *Ohio Farmer* 101, no. 5 (January 30, 1902): 106.

Papadakis, Andreas C. ed. *Deconstruction II*. London: Architecture Design, 1999.

Peck, Amelia, ed., *Interwoven Globe: The Worldwide Textile Trade, 1500–1800*. New York: Metropolitan Museum of Art, 2013.

Poiret, Paul. *En habillant l'époque*. 1930. Paris: Grasset, 1978.

Pollard, Moyra Clare. *Master Potter of Meiji Japan: Makuzu Kōzan (1842–1916) and His Workshop*. New York: Oxford University Press, 2002.

Society for the Study of Japonisme. *Japonisme in Art: An International Symposium*. Tokyo: Kodansha, 1980.

Stinechecum, Amanda Mayer. *Kosode: 16th–19th Century Textiles from the Nomura Collection*. New York: Japan Society and Kodansha, 1984.

Suoh, Tamami. "Exported Dressing Gowns of the Meiji Period." In *The Elegant Other: Cross-cultural Encounters in Fashion and Art*, 187–88. Tokyo: Rikuyosha, 2017.

Thieme, Otto Charles. *With Grace and Favour: Victorian and Edwardian Fashion in America*. Cincinnati: Cincinnati Art Museum, 1993.

Vlastos, Stephen. *Mirror of Modernity: Invented Traditions of Modern Japan*. Berkeley: University of California Press, 1998.

Vollmer, John E. *Re-envisioning Japan: Meiji Fine Art Textiles*. Milan: Five Continents Editions, 2016.

Watanabe, Toshio. *High Victorian Japonisme*. Bern: Peter Lang, 1991.

"Woman's Kimono." *Harper's Bazaar* 32, no. 2 (June 1901): 168.

Yonemura, Ann. *Yokohama: Prints from Nineteenth-Century Japan*. Washington, DC: Sackler Gallery, 1990.

Yoshioka, Sachio. *Sarasa, Printed and Painted Textiles*. Vol. 20 of Kyoto Shoin's Art Library of Japanese Textiles. Kyoto: Fujioka Mamoru, 1993.